IMAGES
of America

AROUND
GENESEO

IMAGES
of America

AROUND
GENESEO

William R. Cook and Daniel J. Schultz

ARCADIA

Copyright © 2004 by William R. Cook and Daniel J. Schultz
ISBN 0-7385-3496-X

First published 2004

Published by Arcadia Publishing,
an imprint of Tempus Publishing Inc.
Portsmouth NH, Charleston SC,
Chicago, San Francisco

Printed in Great Britain

Library of Congress Catalog Card Number: 2003115045

For all general information, contact Arcadia Publishing:
Telephone 843-853-2070
Fax 843-853-0044
E-mail sales@arcadiapublishing.com
For customer service and orders:
Toll-free 1-888-313-2665

Visit us on the Internet at www.arcadiapublishing.com

CONTENTS

INTRODUCTION

For readers who are unfamiliar with Geneseo, let us introduce you to our community. The name Geneseo, an Iroquois word meaning "beautiful valley," is descriptive of where we live. Our town is perched on a hill overlooking the valley of the Genesee River. We live about 25 miles south of Rochester and about 60 miles east of Buffalo. Our town was established by members of the Wadsworth family shortly after the end of the American Revolution. Geneseo was designated the county seat when Livingston County was formed in 1821. Perhaps the most significant addition to the village came in 1871, when a teacher training school opened its doors. Now, the State University of New York at Geneseo more than doubles the population of the village when its 5,000 students are on campus, and SUNY Geneseo is the county's largest employee.

This book contains only glimpses of Geneseo and its neighbors. It cannot be otherwise, for how can we capture more than 200 years of history in a small volume? Everyone who looks at the photographs that follow will put the volume down and wonder, "How could Bill and Dan have left out ——?" However, we think that everyone will also find a few surprises, and we hope that all those who spend some time with the book will agree that it captures the spirit of who we are and what we are.

There are two basic photographic collections that we made use of. The first is one that Bill created while doing research for his 2000 book *Celebrating Our Past: Livingston County in the Twentieth Century*. The process of creating that book involved searching the photograph collections of town historians, numerous organizations, and many private family treasures. Almost 1,500 photographs were scanned. Bill again thanks all those people who allowed him to examine and borrow from their priceless treasures. Livingston County administrator Nick Mazza graciously supplied us with CD-ROMs containing that collection. We also made extensive use of the photographic archives of the Livingston County historian. We thank the recently retired county historian, Pat Schaap, for the user-friendly organization of the collection and the acting county historian, Amie Alden, for her assistance in accessing the photographs we needed and in providing us with much useful information.

As the title of the book indicates, we have focused on the village and town of Geneseo. However, we believe that our picture of life in Geneseo is incomplete without including our neighbors. In a practical vein, presenting life in Geneseo is easier when we include the towns of Avon, Groveland, Leicester, Livonia, Mount Morris, and York because photographs from neighboring towns and villages fill lacunae in the surviving record of Geneseo. More importantly—although we in Geneseo know that Sonyea is in the town of Groveland, that for

almost 100 years there was a salt mine in the town of York, and that the Genesee Valley Canal passed through downtown Mount Morris—all of these places seem integral to the life of Geneseo.

In choosing the photographs presented here from many thousands that we examined, we have privileged older ones. We want this volume to serve as a book of memory and historical record; hence, for the most part we have selected images that cannot be re-created today. There are very few photographs of buildings that are still standing and that look much like they have looked for a century. We wish to stimulate historical imagination, not reproduce what we see today as we meander through the central portion of Livingston County. However, we have made a few exceptions, one of which is in the chapter "The College," because of the enormous growth of SUNY Geneseo in the 1960s and the changing role of the college in the village.

We have also chosen photographs of people more often than ones of sites, however beautiful our architectural heritage and countryside. This book does not seek to survey Geneseo but does hope to show the people of Geneseo who their forebears were and how they lived their lives where we live today.

We have only one photograph that documents the oldest inhabitants of our area, the Native Americans. In the other photographs, we see primarily immigrants and their descendants from various parts of Europe, but we also discover that people of African descent have been part of the population of Geneseo since its founding more than 200 years ago. Although the arrival of a significant number of Asians and Hispanics has taken place in the last few decades and thus is not present in the old pictures, we have included two recent photographs in the chapter "School Days" to remind everyone of the constant change in the makeup of those who call Geneseo and its neighboring communities their home.

We want everyone who lives in and near Geneseo to experience "home" as they look at these photographs. Geneseo's residents have always welcomed new individuals and groups as they settle in the Genesee Valley. This book equally belongs to all of Geneseo's inhabitants today, whether their families have been here for several generations and can trace their ancestry to the valleys of the Thames or Rhine or Liffey or Tiber or Congo, or whether they are new arrivals to Geneseo from the valleys of the Rio Grande or Mekong.

—William R. Cook and Daniel J. Schultz

One
THE NATURAL ENVIRONS

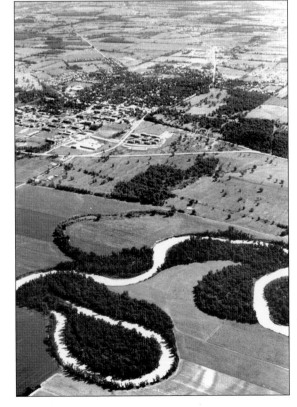

This spectacular c. 1970 photograph
shows the Genesee River in the
foreground with a panoramic view
of the town above. Already, some of
the modern features of the village,
including the expansion of the college,
the Indian Meadows neighborhood,
and the first supermarket on Route
20A, are present. However, there is no
Wal-Mart or the current Geneseo
Central School.

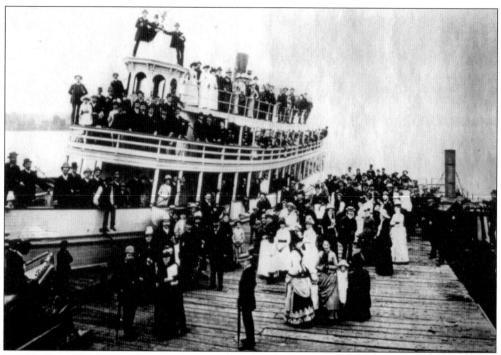

Local folks, plus hordes of tourists who took the train from Rochester, enjoy a day on Conesus Lake *c*. 1900. The steamship is the *McPherson*. (Courtesy Livonia town historian.)

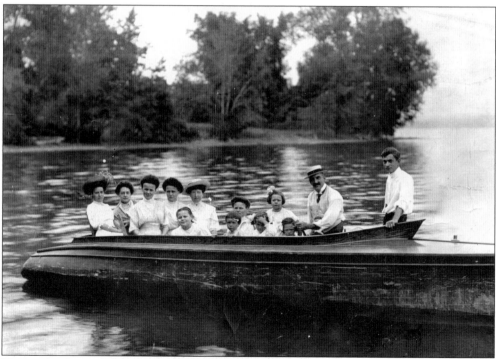

The outfits have changed and the boats are a bit sleeker today than they were when this photograph was taken, but local folks still enjoy being on Conesus Lake. (Courtesy Walt Isaac.)

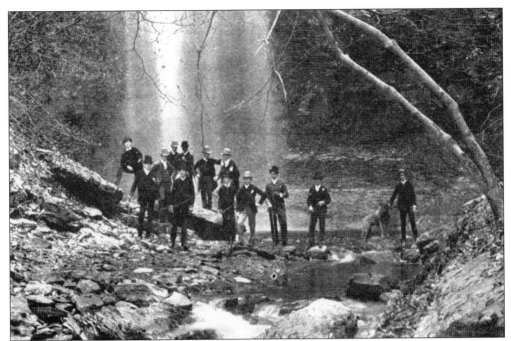

It is not known exactly what these men are doing at Fall Brook, just south of the village of Geneseo. In other eras, the hidden-away spot was a place to cool off, have a picnic, and even do a bit of skinny-dipping. Despite their formality attire, the men are apparently enjoying themselves. (Courtesy Livingston County historian.)

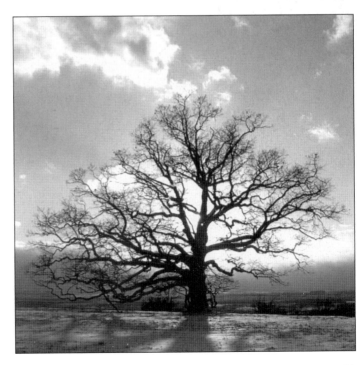

Geneseo residents have always known that they were home when they spotted the famous Wadsworth oaks. (Courtesy Dick Thomas.)

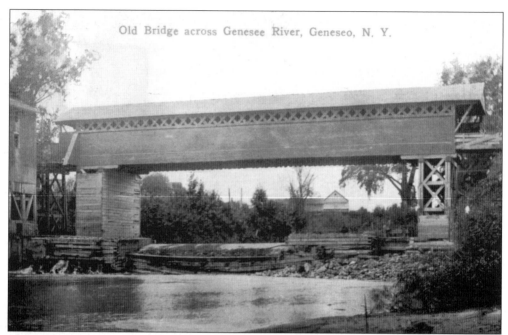

Old Bridge across Genesee River, Geneseo, N. Y.

Covered bridges were necessary to ensure that crossing the Genesee River could take place all year long. This is the bridge that connected the towns of Geneseo and York on what is now Route 63. (Courtesy Geneseo town historian.)

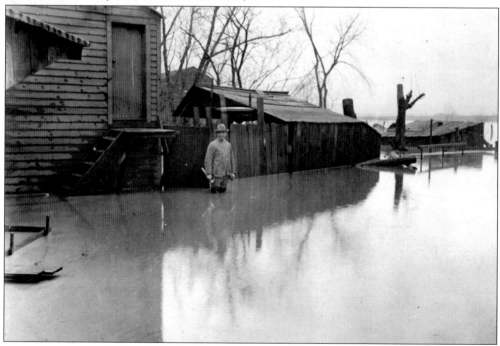

It is not completely clear what this man is about to do with his trusty hammer. However, his predicament is clear: the Genesee River has overflowed its banks in Mount Morris. This 1916 flood provides evidence for the need to tame the mighty Genesee. (Courtesy Livingston County historian.)

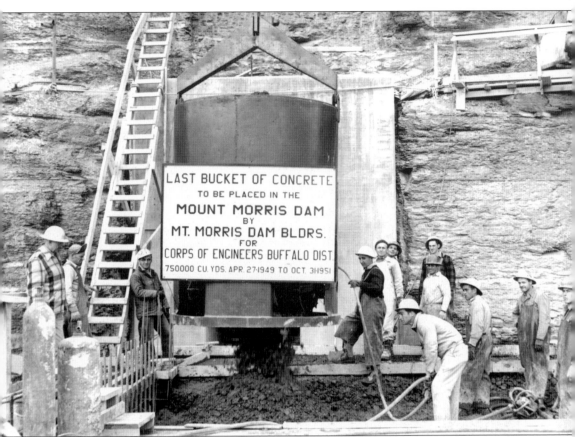

The Genesee River's periodic floods caused great damage both in Livingston County and in Rochester. After World War II, the U.S. Army Corps of Engineers designed and constructed the Mount Morris Dam. Without it, Geneseo and other places located on the banks of the Genesee would have suffered grave damage during the flood of 1972. (Courtesy Mount Morris town historian.)

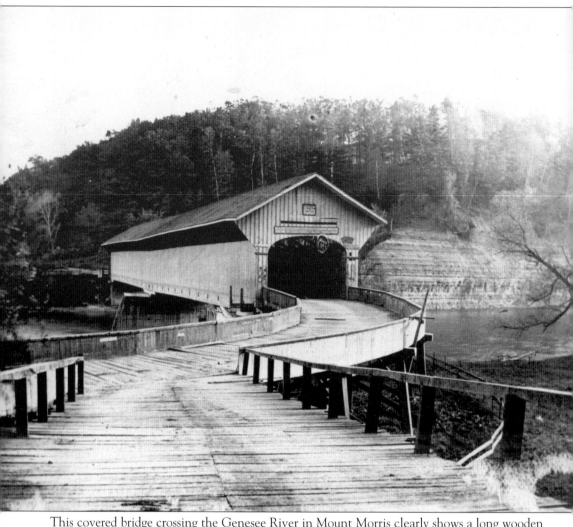

This covered bridge crossing the Genesee River in Mount Morris clearly shows a long wooden roadway leading up to it.

The Genesee Valley Canal passed within a couple miles of Geneseo, making its way through the hamlets of York, Piffard, and Cuylerville before crossing the Genesee River at Mount Morris. Pictured is York Landing, where canal boats could dock and turn around. The canal was abandoned in 1877. The men are rather formally dressed for fishing. (Courtesy Livingston County historian.)

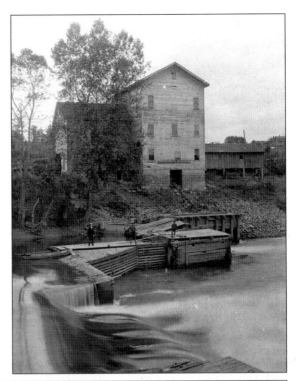

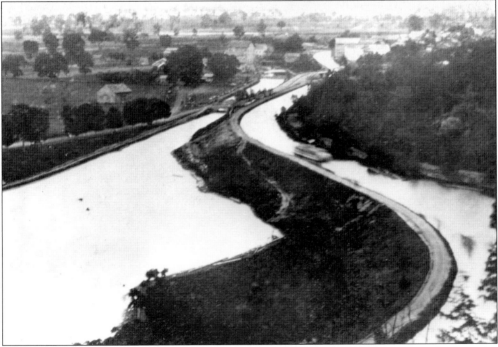

The Genesee Valley Canal changed the landscape of Mount Morris when it was built in the 1840s. This damaged but rare photograph of the canal, complete with a boat, testifies to a time when Geneseo's neighbor had an "artificial river" as one of its principal streets. (Courtesy Livingston County historian.)

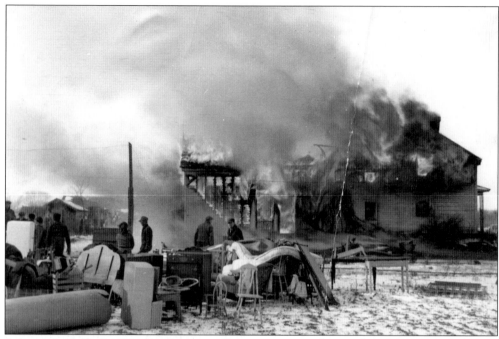

A fire on Jones Bridge Road in the town of Leicester is a vivid reminder of the property damage that fire can cause. It is also a reminder of the importance of volunteer firefighters, since Geneseo and its neighbors have always relied on them. See chapter 4. (Courtesy Leicester town historian.)

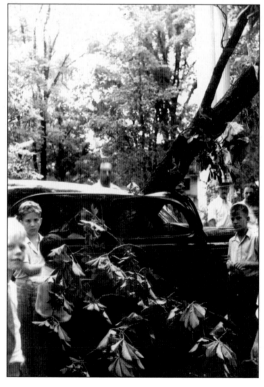

A storm in Mount Morris *c.* 1937 did great damage to someone's precious automobile. (Courtesy Mount Morris Historical Society.)

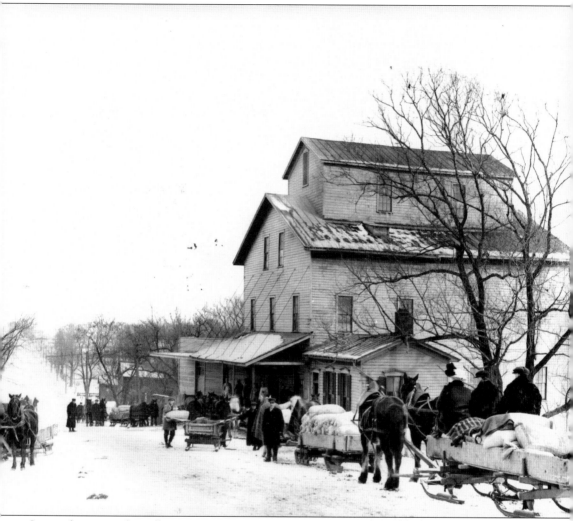

Snow often turns the valley into a winter wonderland but also creates challenges. Before paved roads and trucks, people used sleighs to transport goods in the winter. In this c. 1900 photograph, materials are being delivered to a feed mill in Mount Morris. (Courtesy Mount Morris town historian.)

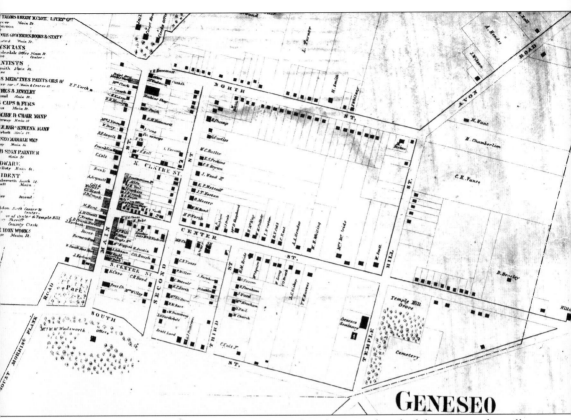

GENESEO

This 1858 map of the village of Geneseo shows that the central grid of the present-day village has not changed much over the last century and a half except for the addition of Oak Street at the end of the 19th century. Originally, Geneseo was laid out in the form of a New England village, but it was soon transformed into the more "modern" type of town seen here. Despite essential continuity, this map contains many surprises for village residents today. There is no college or Wadsworth Street. Ward Place and Chestnut Street are called North and South Centre Street, respectively. Elm Street was then called Third Street. The house marked "A. Ayrault," on Main Street, is now the Big Tree Inn. Temple Hill Academy is called the Geneseo Academy, and the cobblestone schoolhouse on Centre Street, now the Livingston County Historical Museum, is labeled "SH." The Catholic church was across North Street from where St. Mary's stands today. (Courtesy Livingston County historian.)

Two
MAIN STREET

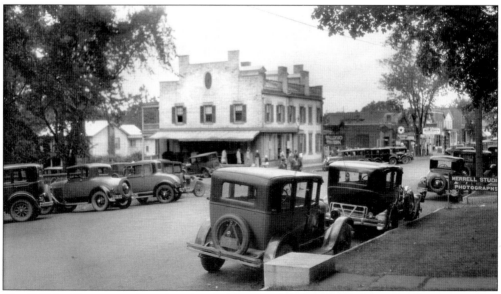

The Tallyho Tavern stood on the corner of Main and Park Streets in Geneseo. The business at the star sign, farther to the right, is a garage and gas station with two pumps are visible. Note the boy trying to shinny up one of the poles on the porch of the Tallyho. (Courtesy Livingston County historian.)

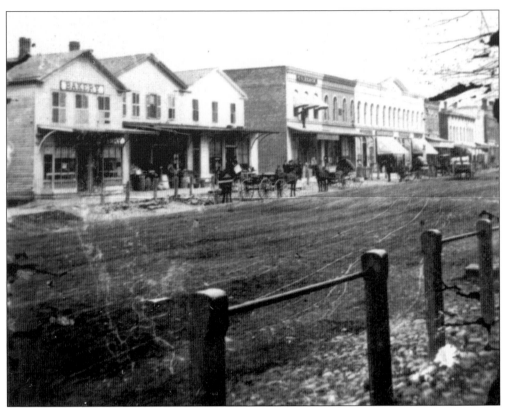

With the hitching post in the foreground and the dirt street, Geneseo looks like a town in the Wild West. (Courtesy Livingston County historian.)

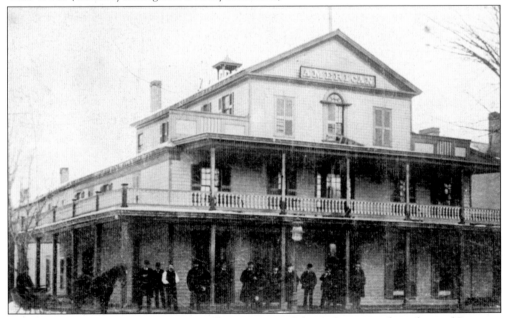

This snowy day at the American Hotel in Geneseo did not keep people indoors. (Courtesy Livingston County historian.)

Main Street in Geneseo is the gathering place for this automobile rally. The car on the right, with a woman driver, has a license plate bearing the year 1913. (Courtesy Livingston County historian.)

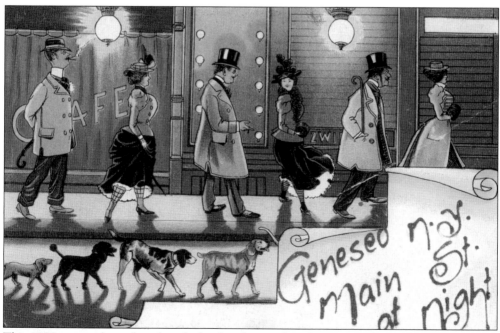

This 1909 postcard may be a bit idealized with regard to Geneseo's urbane qualities (note the cafe, street lamps, elegant dogs, and well-dressed strollers), but it is a reminder that Geneseo was far different from the frontier town it had been a century earlier. (Courtesy Tom Roffe.)

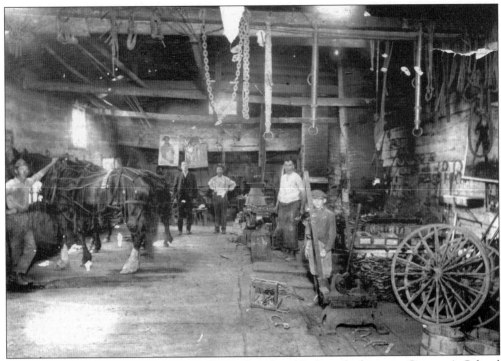

The work was hard but important at the McCaughey blacksmith shop, on Geneseo's School Street. (Courtesy Geneseo town historian.)

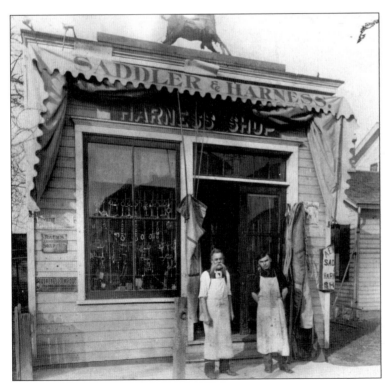

The Kemp harness shop was located on Genesee Street in Mount Morris. In this 1909 view, the proprietors take a break from their work to pose in front of the shop. (Courtesy Mount Morris Historical Society.)

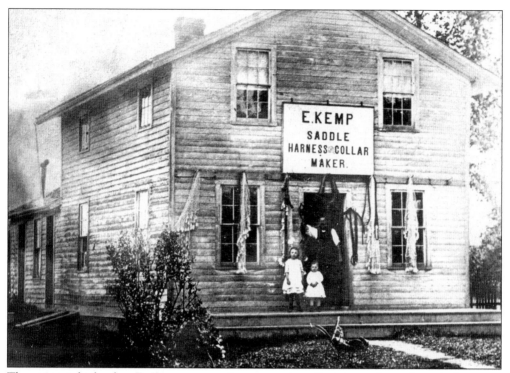

There is no doubt that E. Kemp was an important manufacturer and merchant in Leicester before the automobile came to town. In this photograph, Kemp is posing with his two young daughters. (Courtesy Livingston County historian.)

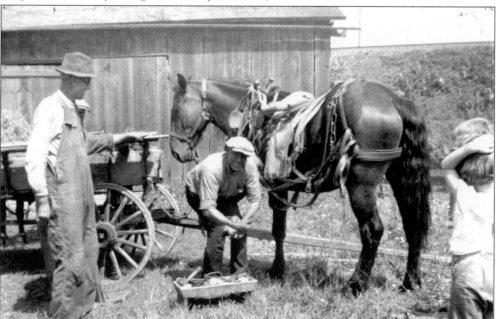

Shoeing a plow horse was important business before the coming of gasoline-powered engines. Putting a new left front shoe on this horse has attracted the attention of the children on the right. (Courtesy Leicester town historian.)

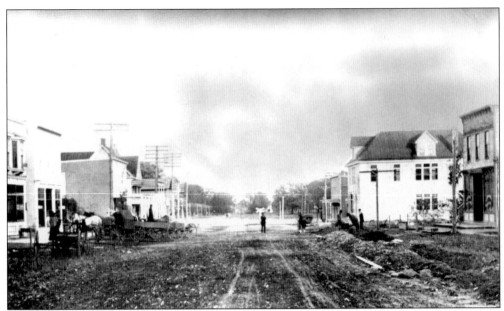

The village of Moscow (now Leicester) at the beginning of the 20th century may look a bit like a set for an old western movie. However, the signs of change are present in the power wires, the railroad crossing sign, and the laying of pipes (right). With the coming of the automobile, Main Street was paved and Leicester took on the look of a modern town. (Courtesy Leicester town historian.)

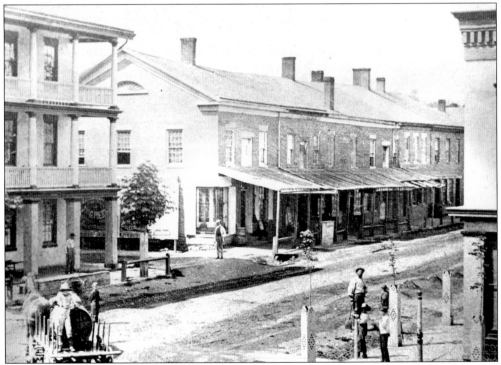

Wooden sidewalks and splendid buildings mark downtown Mount Morris in the late 19th century. (Courtesy Livingston County historian.)

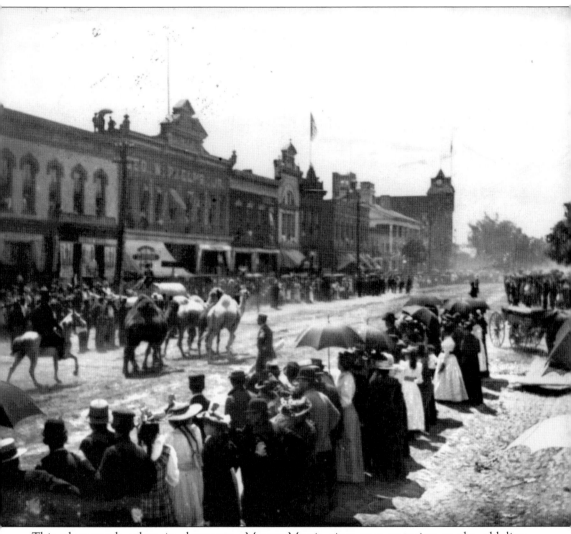

This photograph taken in downtown Mount Morris gives new meaning to the old line "The camels are coming." The arrival of the circus and other traveling entertainments generated great excitement before the era of easy travel and television. (Courtesy Mount Morris town historian.)

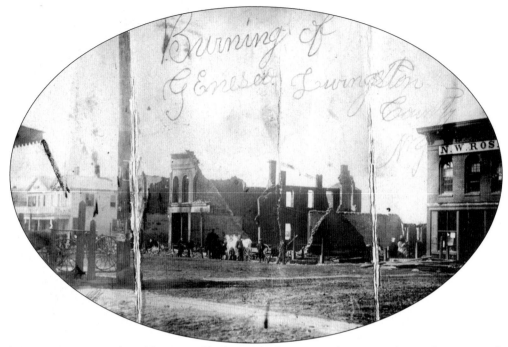

Main streets were vulnerable to terrible fires. The last major downtown fire in Geneseo took place in 1970. This one occurred a century earlier. (Courtesy Livingston County historian.)

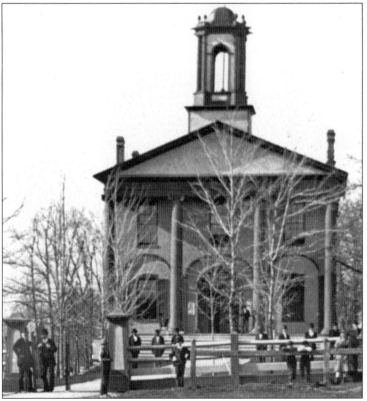

Geneseo became the seat of newly created Livingston County in 1821. The courthouse at the north end of Main Street, shown here with some of its employees standing in front, required fundamental repair and rebuilding just before the beginning of the 20th century. (Courtesy Livingston County historian.)

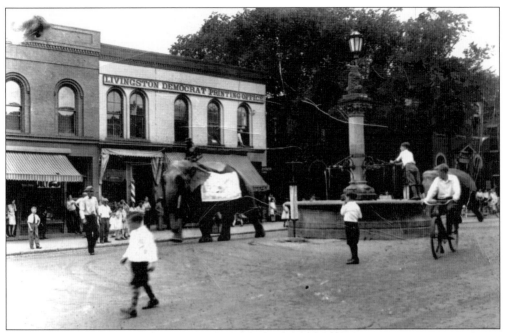

Everyone loves a circus, especially when it literally comes right to your door. Two elephants stroll by the bear fountain on Main Street to lure crowds to a performance. In the background is the office of the Livingston Democrat; needless to say, there was also a Livingston Republican in Geneseo. (Courtesy Geneseo town historian.)

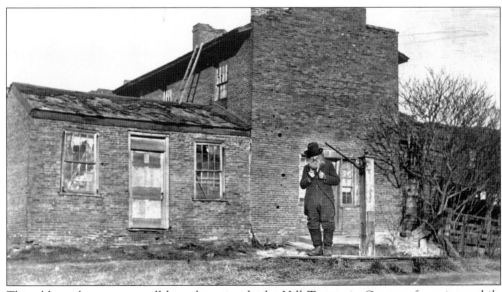

This old gentleman may well have been inside the Hill Tavern in Geneseo for quite a while before posing for this photograph. This watering hole was a far cry from some of the elegant establishments in town. (Courtesy Livingston County historian.)

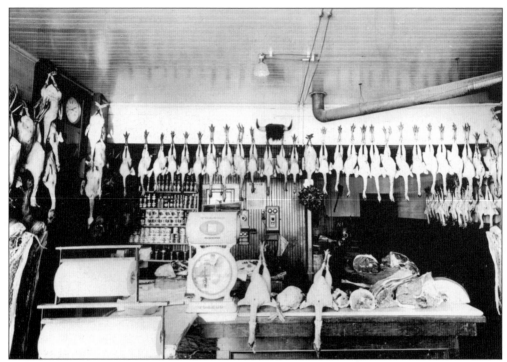

Although this Avon store sold meat and canned goods, it was primarily a poultry store. In addition to the numerous chicken dinners to be served in Avon on the evening that this photograph was taken, a couple of prosperous families could look forward to dining on goose. (Courtesy Avon town historian.)

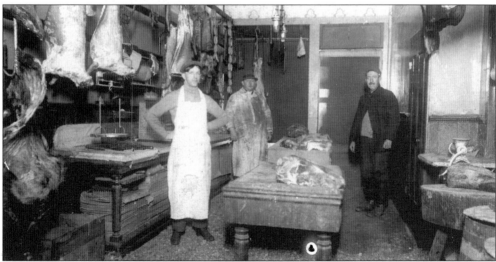

The Haley Meat Market was located on Main Street in Geneseo. These butchers and the food they prepared are shown c. 1900. (Courtesy Geneseo town historian.)

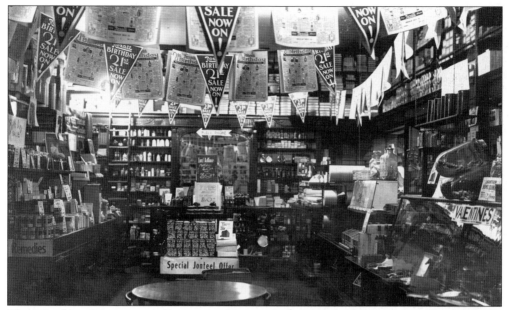

The Minckler drugstore, in Geneseo, sold just about everything. A sign on the left is for "Remedies," and Jonteel soap is on sale along with peppermint patties in the middle display. Stick candy can be seen on the shelves to the right, and Valentines are also in season. The arrow in the center points patrons toward the public telephone. (Courtesy Livingston County historian.)

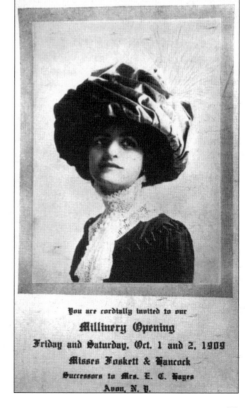

You are cordially invited to our
Millinery Opening
Friday and Saturday, Oct. 1 and 2, 1909
Misses Foskett & Hancock
Successors to Mrs. E. C. Hayes
Avon, N. Y.

This 1909 advertisement for a new enterprise in Avon makes it clear that the most stylish fashions could be purchased in Livingston County. (Courtesy Avon town historian.)

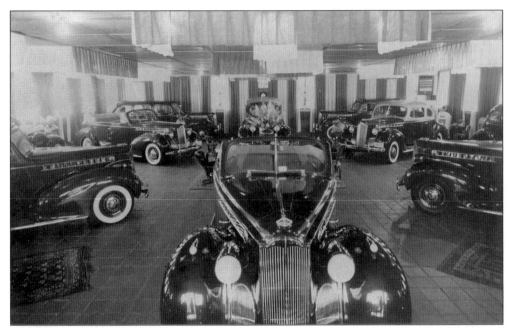

The Conlon-O'Leary automobile showroom in Mount Morris has a wide variety of newly arrived 1937 Packards to choose from, including convertibles and two-tones. Did the buyer of the one in the center also get the bouquet of flowers sitting on the car roof? (Courtesy Kay Conlon.)

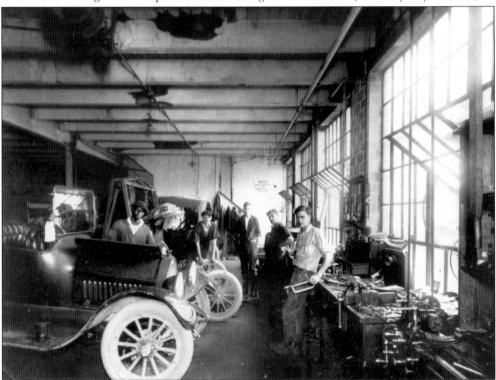

This garage on Geneseo's Main Street employed white and African American mechanics. (Courtesy Livingston County historian.)

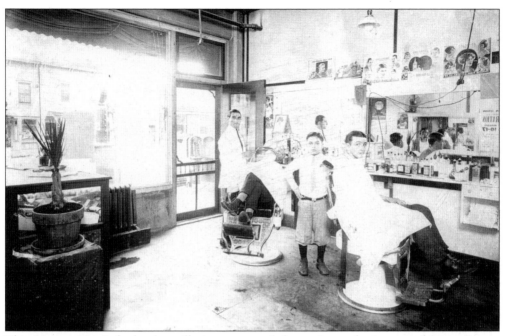

This Mount Morris barbershop illustrates one of the mainstay businesses of Main Streets everywhere. A direct descendant of this barber operates a shop on Main Street in Geneseo today. This photograph was taken in 1917. A poster on the right reminds patrons of rationing that was put into effect during World War I. (Courtesy Richard Peraino.)

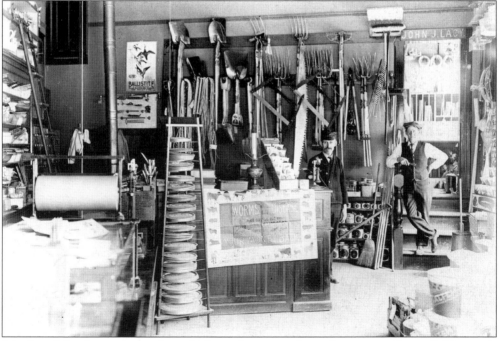

John Lacy's hardware store in Avon had just about everything, from pots and pans (left) to tools and seeds and even a churn (right). The large sign advertises a product that promises to ward off disease in livestock.

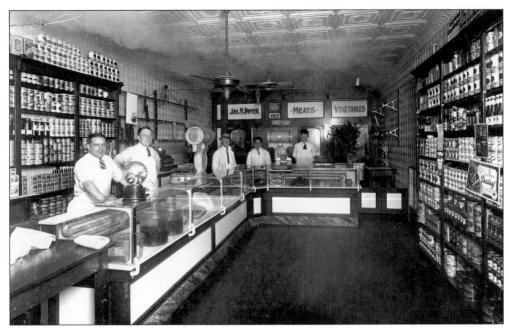

This 1923 photograph of Dwyer's grocery store, in Geneseo, shows the latest refrigeration technology in the cases. The gumball machine on the counter was obviously to occupy the youngsters while mom shopped. (Courtesy Livingston County historian.)

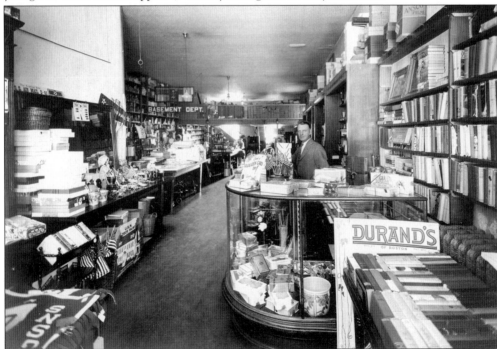

This Geneseo bookstore sold many things other than books. There are boxes of candy in the cases, some toys on the table to the left, lots of American flags, and even knives and kites. To the lower left is a pile of GSNS banners; at the time this photograph was taken, the college in Geneseo was known as Geneseo State Normal School. (Courtesy Livingston County historian.)

Three
BUSINESS AND INDUSTRY

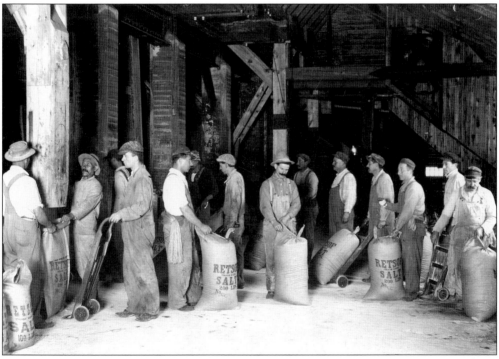

Salt mining has been an important part of the area's economy for more than 100 years and continues to be so with the new mine in Groveland. In the first century of mining, some 100 million tons of salt were removed. The business of salt mining also extended to packing and shipping it. In this view, men fill 200-pound sacks. Most of the men in the photograph were immigrants from Italy. (Courtesy Livingston County historian.)

Salt was shipped in barrels as well as bags. Here, men make barrels in which the salt was placed. (Courtesy Joe Bucci.)

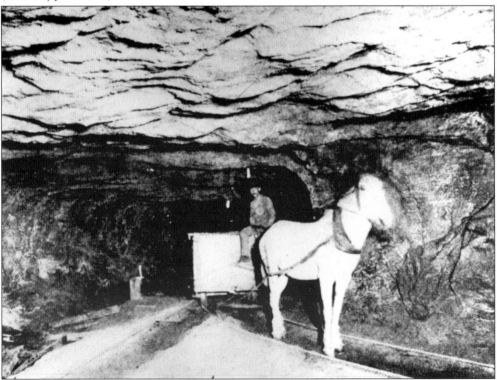

Before the installation of a railroad system, salt was brought to the surface in cars on tracks pulled by mules. This photograph was taken in the Retsof mine. (Courtesy Joe Bucci.)

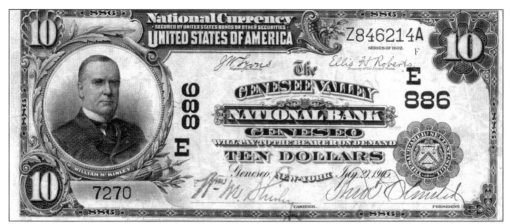

Despite the appearance of this bill, Geneseo did not have its own currency. However, the Genesee Valley National Bank was one of many banks throughout the United States that issued U.S. currency until bank reforms of the New Deal era. This $10 bill, issued in 1905, was good anywhere in the country.

This flour sack illustrates that fact that many of the local industries were the result of the area's agricultural riches. (Courtesy Kenneth C. Gernold.)

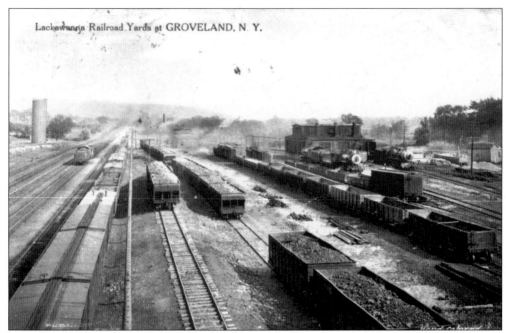

The Lackawanna Railroad yard at Groveland Station shows by its size that it was an important transportation hub. The famed train *Phoebe Snow*, whose jingle was "Climb aboard the *Phoebe Snow*, and shuffle off to Buffalo," passed through here. (Courtesy Mrs. Robert Kane.)

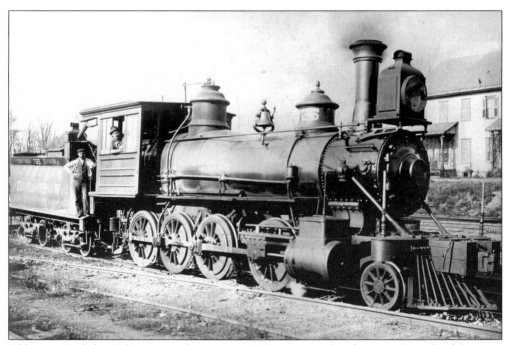

Old No. 26 of the Delaware, Lackawanna and Western Railroad sits in Groveland Station. (Courtesy Livingston County historian.)

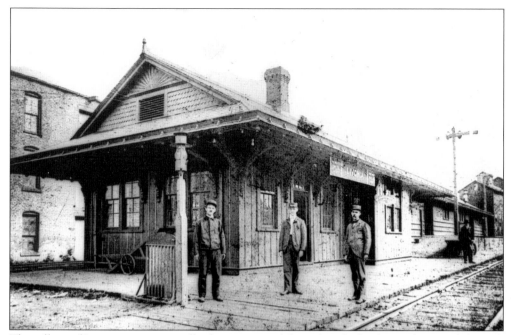

The village of Livonia was essentially the creation of the railroads, for the tracks passed through there rather than through the older hub in the town of Livonia, Livonia Center.

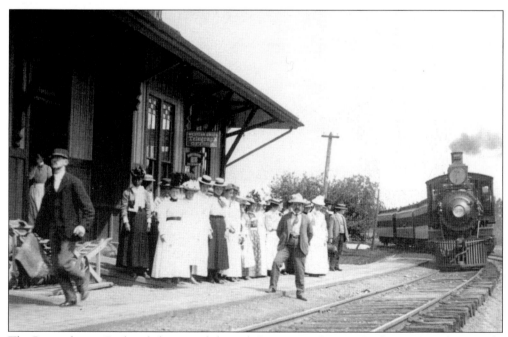

The Pennsylvania Railroad also passed through Livingston County. In this *c.* 1900 photograph, a group of women awaits the arrival of a train at the station in Sonyea.

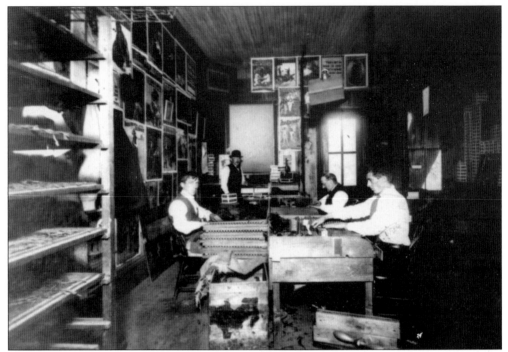

Geneseo was home to the Lowrey cigar factory in the early 20th century. (Courtesy Livingston County historian.)

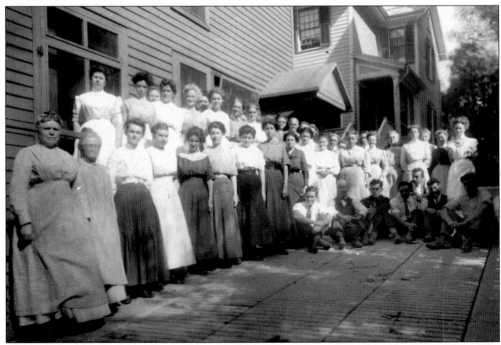

Thirty-four women and seven men make up the workforce in Geneseo's jam kitchen. This business was owned and run by women, unusual for the early 20th century. (Courtesy Livingston County historian.)

38

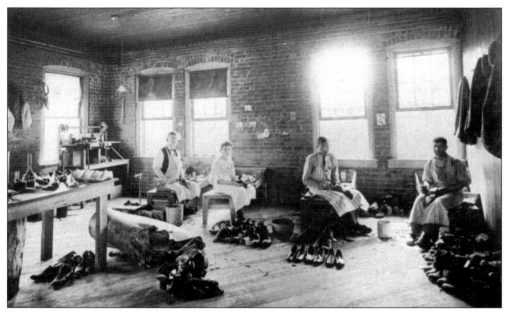

Shoemakers are pictured working at their craft in Sonyea (town of Groveland), an acronym for State of New York Epileptic Asylum. The patients at Sonyea had their own largely self-contained community. (Courtesy Livingston County historian.)

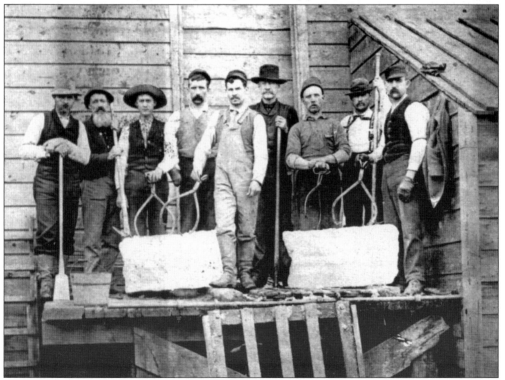

Conesus Lake supplied Geneseo with not only water and a place for recreation but also a means of refrigeration throughout the year. Until the coming of electricity into homes, the icehouse was an important business in the community. (Courtesy Livonia town historian.)

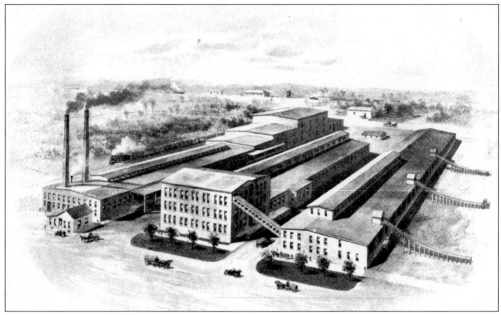

Because of its rich mucklands, the Genesee Valley contained several important food-processing plants. This drawing shows the Winters and Prophet Canning Company of Mount Morris, which employed hundreds of people—many of them recent immigrants from Italy—at the beginning of the 20th century. (Courtesy Mount Morris town historian.)

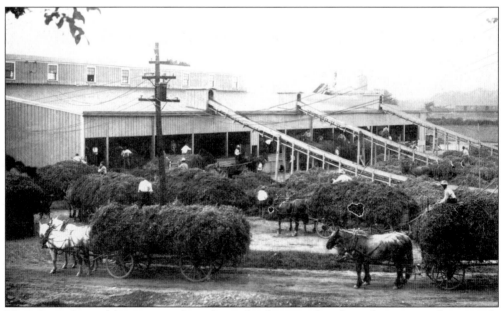

These long chutes (also seen on the right in the drawing above) are for carrying the recently harvested vegetables, in this case peas, into the plant for processing. (Courtesy Mount Morris town historian.)

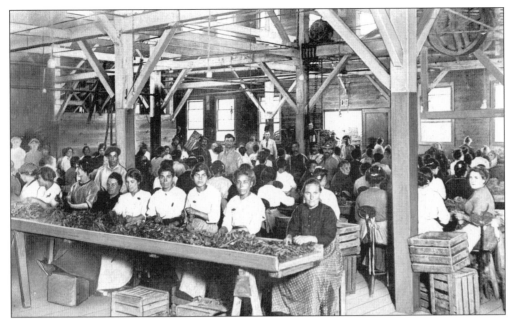

Spinach is inspected before being processed. Many of these women's husbands did the harvesting. It is interesting to see that the supervisors are men. (Courtesy Mount Morris town historian.)

There was once heavy industry in Fowlerville, a small hamlet in the town of York. Farm equipment and, later, nuts and bolts were manufactured in this factory. (Courtesy Livingston County historian.)

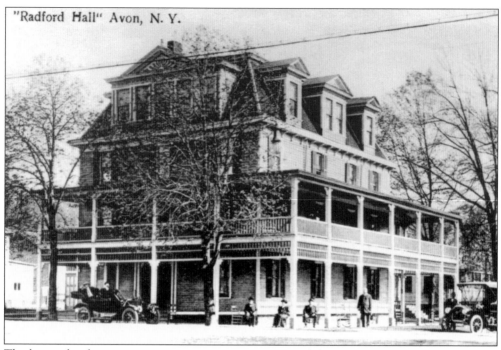

"Radford Hall" Avon, N. Y.

The hospitality business was important to a society as mobile as America was. Avon, touting health spas and located on the main east-west road, had several important hotels, including Radford Hall, constructed *c.* 1877. (Courtesy Avon town historian.)

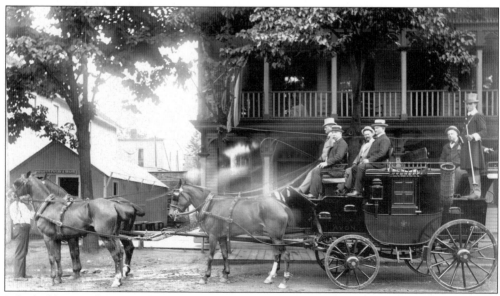

It looks like a well-liveried herald is announcing the arrival or departure of this stagecoach in Avon. (Courtesy Livingston County historian.)

Four

CIVIC LIFE

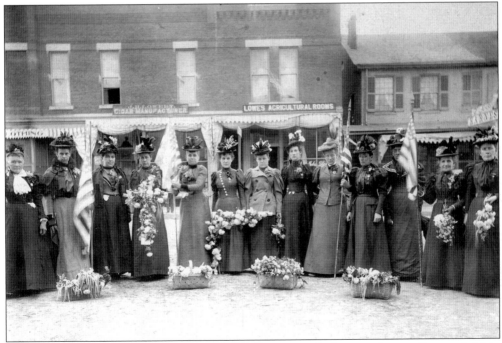

With a clothing store, a cigar factory, agricultural rooms, and a harness shop on Geneseo's Main Street for background, members of the Women's Relief Corps—originally an organization of the wives of Civil War veterans—prepare for Memorial Day. At that time the holiday, for obvious reasons, was known as Decoration Day. (Courtesy Livingston County historian.)

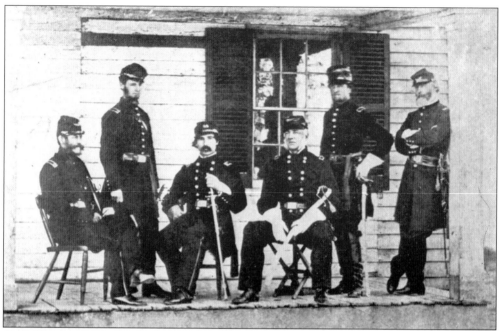

Civil War general James Wadsworth of Geneseo (fourth from the left) and his staff pose for this classic photograph. Wadsworth fought at Gettysburg and was killed at the Battle of the Wilderness. (Courtesy Livingston County historian.)

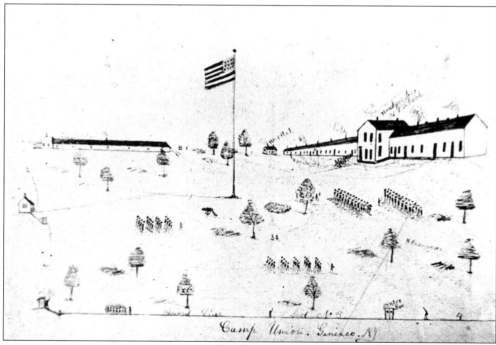

Camp Union, built to train Union soldiers during the Civil War, stood at what now is the corner of Lima Road and Rorbach Lane. To the left of the main building is a hospital. (Courtesy Livingston County historian.)

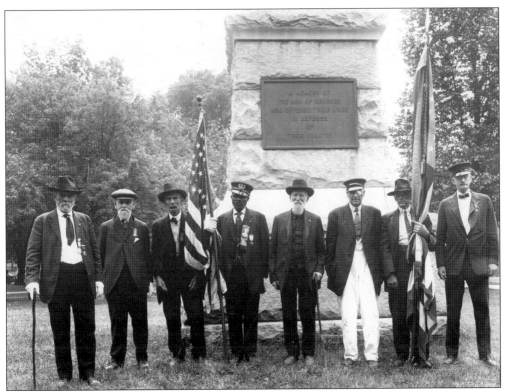

On July 4, 1921, Geneseo's Civil War veterans, members of the Grand Army of the Republic A.A. Curtiss Post 392, pose in front of Geneseo's Civil War monument. At that time, the war's end was 56 years in the past. Note that several veterans have infirmities that, in some cases, were the results of their war service. One of the veterans is African American. (Courtesy Livingston County historian.)

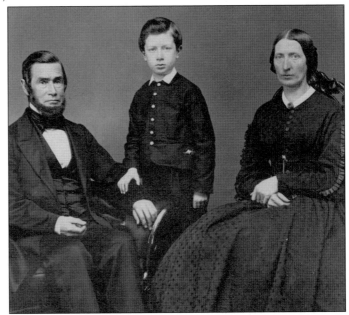

When people from Livingston County say the Pledge of Allegiance, they swell with more than the usual pride because its author, Francis Bellamy (shown here with his parents), was a native of Mount Morris. (Courtesy Mount Morris town historian.)

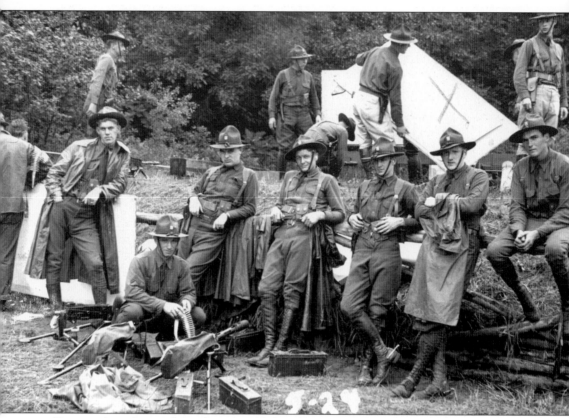

Geneseo, long famous for its horses, prided itself on its cavalry. Here, the men pause to set up camp during their training. They appear to have plenty of ammunition. (Courtesy Livingston County historian.)

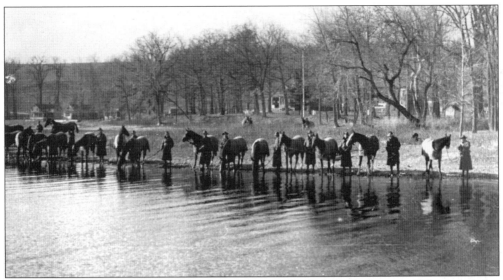

Geneseo's cavalrymen give their horses a chance to drink from the waters of Conesus Lake. (Courtesy Livingston County historian.)

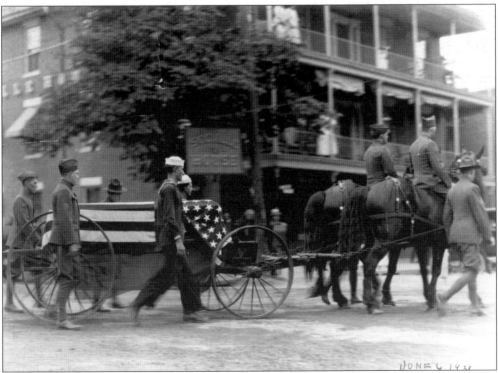

Not all of those who fought in the nation's wars came home alive. Percy Geddes was injured in World War I, eventually dying in a British hospital. In this photograph, his body is honored in his home town, Mount Morris. (Courtesy Mount Morris town historian.)

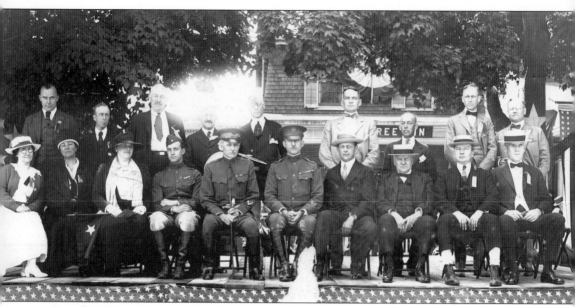

It is clear from the expressions on the faces of these folks that selling war bonds during World War I was serious business. (Courtesy Livingston County historian.)

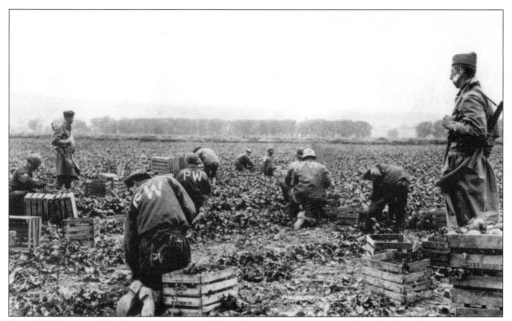

Guarded by armed soldiers, prisoners of war (note the "PW" on their clothes) harvest beets in the town of Groveland during World War II. They were from the POW camp at Stony Brook State Park, south of Dansville. (Courtesy Rochester Public Library.)

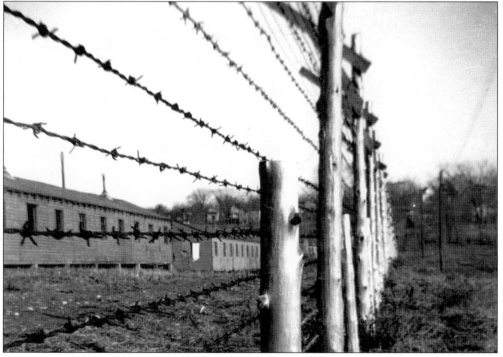

This photograph is a grim and powerful reminder of war. It shows a camp for prisoners of war, largely from Italy, built in Geneseo during World War II. Some of the local people, especially Italian immigrants, brought food to the prisoners and spoke with them in their native tongue. (Courtesy Livingston County historian.)

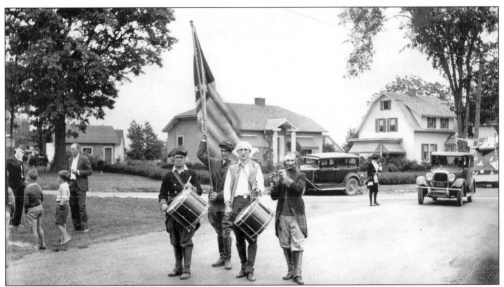

In this photograph, taken in Geneseo in 1932, the "Spirit of '76" and a float (far right) are waiting to participate in a parade held in honor of the village's 100th birthday and George Washington's 200th birthday. (Courtesy Livingston County historian.)

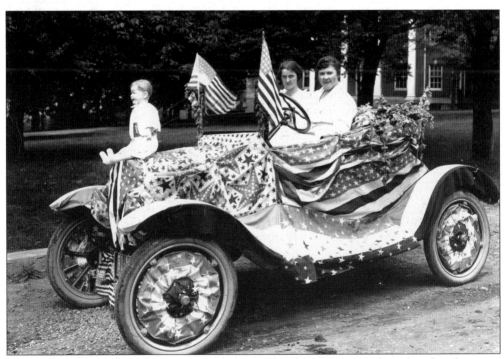

This rather elaborately and whimsically decorated car driven by a newly enfranchised woman was part of the 1921 Fourth of July parade through downtown Geneseo. (Courtesy Livingston County historian.)

Geneseo has always had civic-minded citizens protecting people and property against fires. The banner in the center proclaims that the Wadsworth Hose has won first prize. (Courtesy Livingston County historian.)

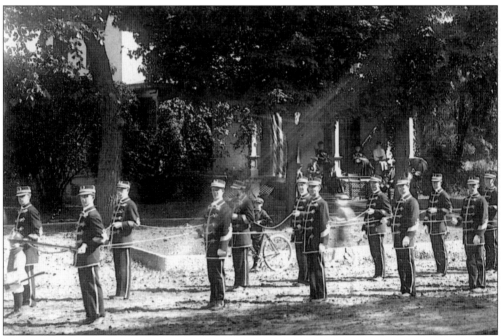

The Temple Hill Hose Company marches down Main Street in Geneseo. In front, with a fire helmet and axe, is a boy who serves as the company mascot. The youths with the bicycles and the women on the porch watch the firefighters approvingly. The fire companies in Geneseo took great pride in their work and in the way they presented themselves to the public. (Courtesy Livingston County Historian.)

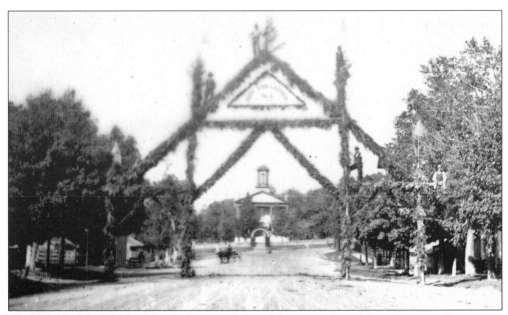

Hook and Ladder No. 1 of Geneseo erected this elaborate arch on Main Street in Geneseo in 1879 as part of the celebration of the 100th anniversary of the Sullivan expedition, which was led by American Revolutionary general John Sullivan. The courthouse in the background was largely replaced by the present structure at the end of the 19th century.

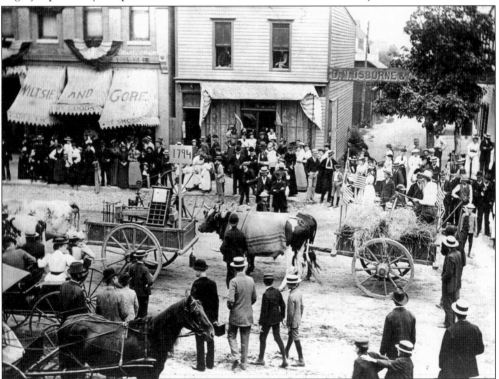

In 1894, the residents of Mount Morris celebrated their village's centennial with an imaginative re-creation of how the first white settlers arrived in Genesee country.

52

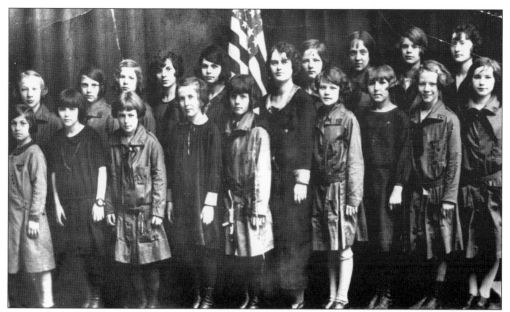

This is Geneseo's first Girl Scout troop. The photograph was taken in the early 1920s, about a decade after the establishment of the Girl Scouts of America. Although many think of cookies when they think of Girl Scouts, these young women were trained for both traditional women's vocations and good citizenship.

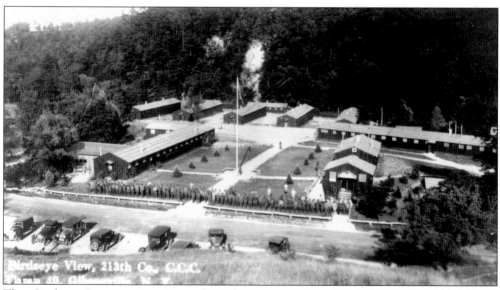

The Civilian Conservation Corps (CCC) was a creation of the New Deal to provide employment. One of the camps was located in Gibsonville (town of Leicester), and its residents turned the beautiful gorge carved by the Genesee River into an inviting Letchworth State Park. (Courtesy Leicester town historian.)

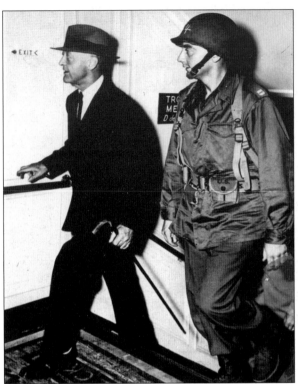

Congressman James W. Wadsworth Jr. of Geneseo and his son Reverdy Wadsworth both contributed to America's victory in World War II. The father pushed for the passage of the Selective Service Act of 1940, and the son served his nation in uniform. (Courtesy Geneseo town historian.)

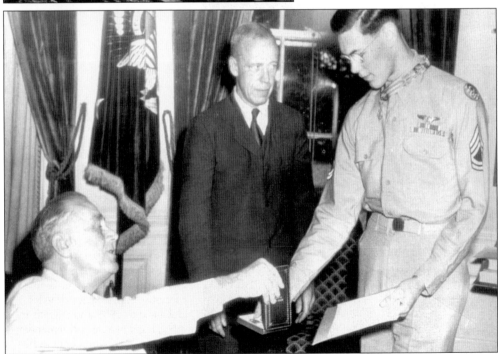

Geneseo and its surrounding towns have been home to heroes of all of America's wars. Here, T.Sgt. Forrest Vossler of Livonia receives his Congressional Medal of Honor from Pres. Franklin Delano Roosevelt in the Oval Office.

When Soviet leader Nikita Khrushchev threw a tantrum at the United Nations, it was Geneseo's James Jeremiah Wadsworth, U.S. ambassador to the UN, who dealt with him. This photograph was made to promote Wadsworth's book *The Price of Peace.* (Courtesy Corrin Strong.)

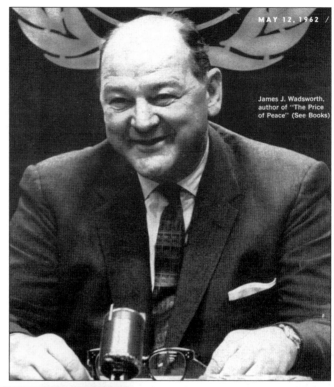

MAY 12, 1962 /

James J. Wadsworth, author of "The Price of Peace" (See Books)

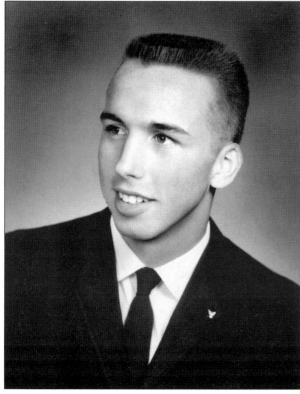

While the world knows Jim Adamson of Groveland as Col. James Adamson, mission specialist on the space shuttles *Columbia* in 1989 and *Atlantis* in 1991, local people still remember him as he is pictured here in his Geneseo Central School yearbook. (Courtesy Geneseo Central School.)

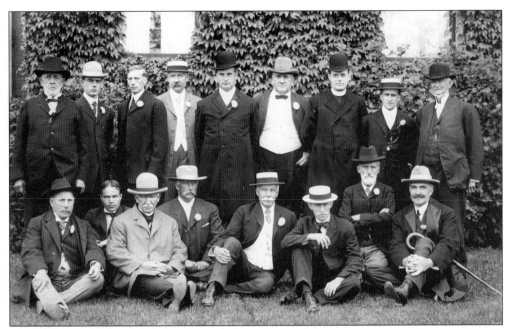

These men, including a priest wearing a bowler, pose for a photograph at Sonyea. They were perhaps a board of overseers. (Courtesy Livingston County historian.)

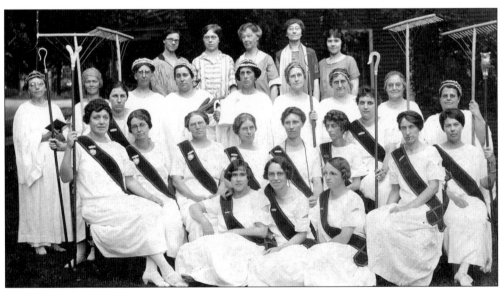

The women of the Grange prepare for a ritual that includes stylized rakes and shepherd's crooks, symbols of the agricultural world that the Grange celebrated and developed. (Courtesy Livingston County historian.)

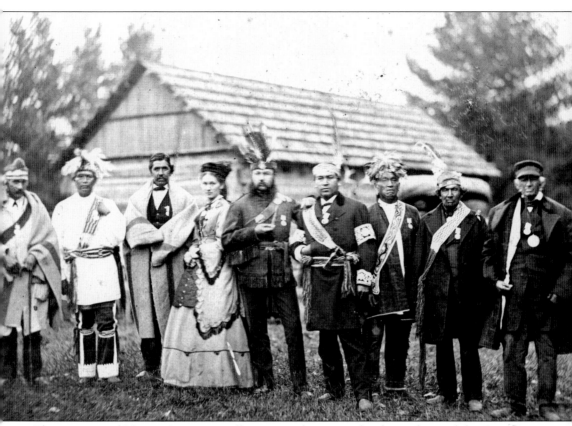

This meeting of Native Americans offers a rare glimpse at the descendants of the Geneseo area's first inhabitants. (Courtesy Livingston County historian.)

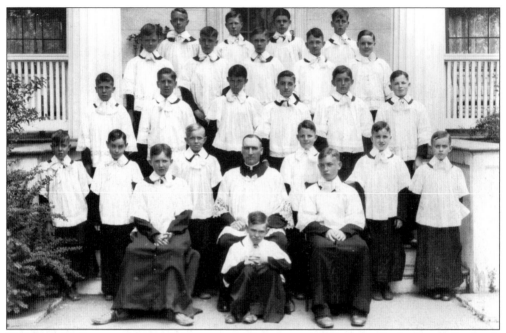

The original white settlers in the area were Protestants, largely from England and Scotland. However, the coming of the Irish in the mid-19th century and of the Italians at the beginning of the 20th century led to the creation of large Catholic communities. Here is the parish priest accompanied by the altar boys of St. Agnes Catholic Church in Avon. (Courtesy Avon town historian.)

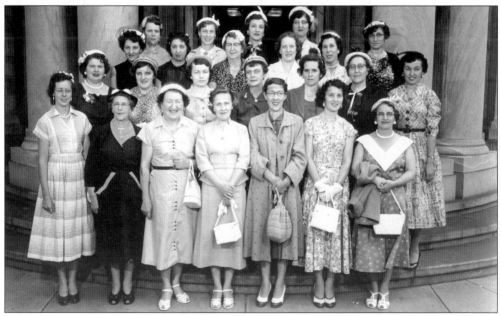

This 1955 photograph shows the women of the Rosary Society of St. Thomas Aquinas Catholic Church in Leicester on a pilgrimage to the Basilica of Our Lady of Victory in Lackawanna. The "uniform," which includes hats and handbags, is a reminder of the more formal public life that existed before the changes of the 1960s. (Courtesy Leicester town historian.)

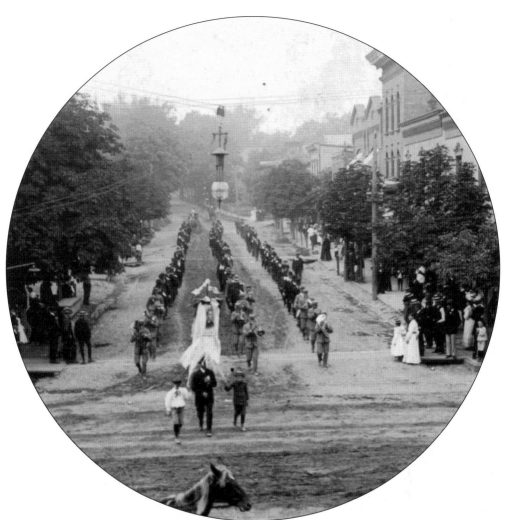

Italian immigrants were particularly numerous in Mount Morris. This photograph from the beginning of the 20th century shows a procession with a *palio* (banner) and band that celebrated the feast of the Assumption of the Virgin Mary, to whom the Italian Catholic church was dedicated. This public display of religion must have seemed strange to the Protestants, who generally did not practice such public expressions of religiosity. (Courtesy Mount Morris town historian.)

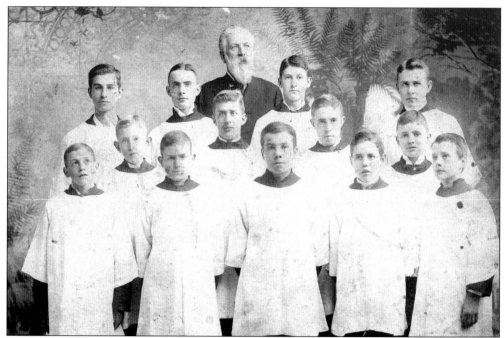

The Anglican (Episcopal) Church has a long tradition of excellent boys' choirs, not just in England but also at St. Michael's Church in Geneseo. (Courtesy Livingston County historian.)

The Geneseo Baptist Church stood at the corner of Bank and Wadsworth Streets from 1886 until it was destroyed in 1927. Today, the site is now part of the campus of SUNY Geneseo. (Courtesy Livingston County historian.)

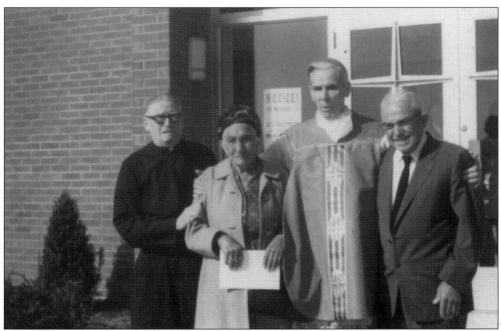

The Geneseo area is part of the Catholic diocese of Rochester. In the late 1960s, the bishop was Fulton J. Sheen (second from the right), who for many years was the nation's best-known preacher through his telegenic personality in *Life Is Worth Living*. Sheen, who has been proposed for sainthood, is pictured on the steps of St. Lucy's Church in Retsof (town of York) with some of his flock. In 1969, he celebrated Mass on the 50th anniversary of his ordination at the Church of St. Raphael in Piffard (town of York). (Courtesy Jim Yasso.)

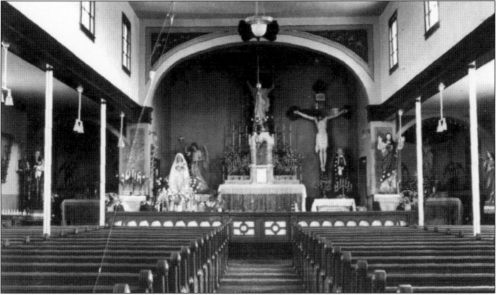

Just as the Catholics' public display of religion was different from that of the early residents of the Geneseo area, so also were the statues that filled Catholic churches—as seen here in the Assumption Church in Mount Morris—the Latin language of the Mass, and the incense used during services. (Courtesy Amelia Laspesa.)

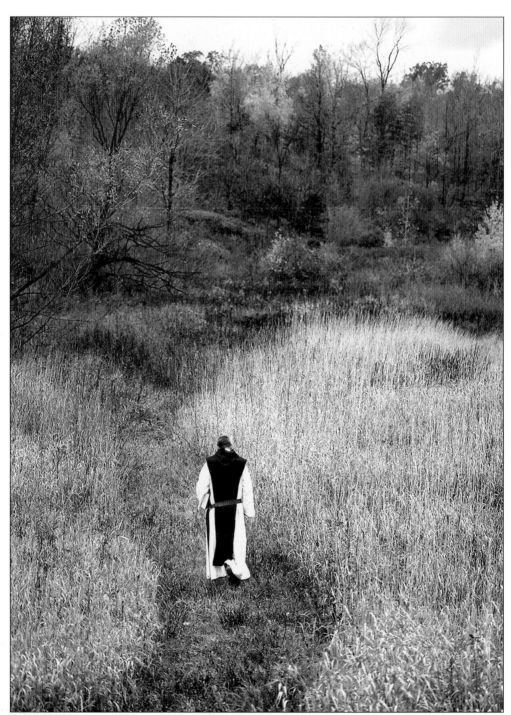

Another facet of religious life in the Genesee Valley is the presence of Catholic monks of the Order of the Cistercians of the Strict Observance (Trappist). The monks of the Abbey of the Genesee have served as a spiritual resource for many local people, not only Catholics, since their arrival a half-century ago. For example, they have sponsored two families from Southeast Asia to settle in the towns of Geneseo and York. (Courtesy Abbey of the Genesee.)

Five

AGRICULTURE
AND RURAL LIFE

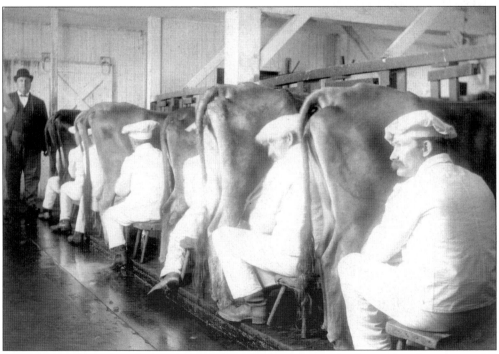

Dairy farming has a long history here, and the Geneseo area's chief agricultural product today is milk. This old milking parlor was at the epileptic asylum at Sonyea, in the town of Groveland. Note the well-dressed supervisor. (Courtesy Tom Roffe.)

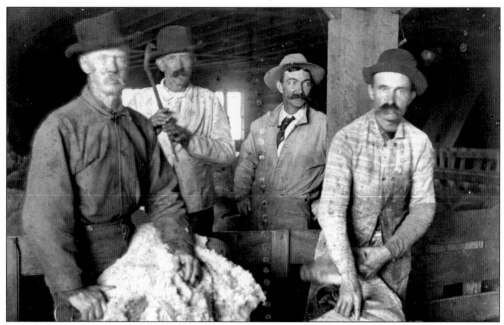

Raising sheep was one of the most important types of agriculture in Livingston County a century ago, when there were 100,000 sheep and lambs. This photograph from Groveland shows a man shearing a sheep while other workers display the fruits of their labor. (Courtesy Livingston County historian.)

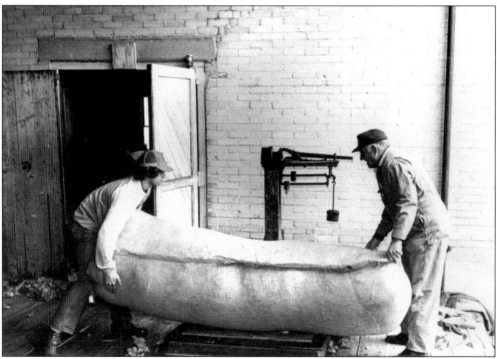

The sheared wool is being put into sacks to ship it to where it will become cloth. (Courtesy Cornell Cooperative Extension of Livingston County.)

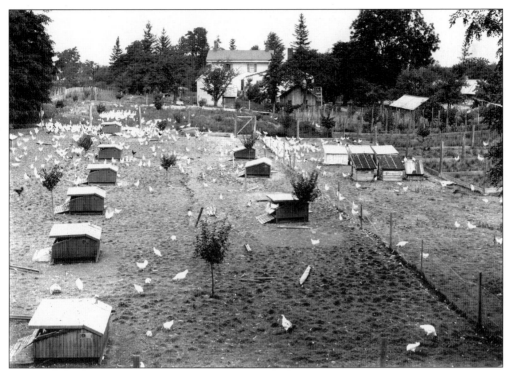

Chickens and geese (beyond the farthest henhouse) provided income for many farmers. This Avon farm perhaps supplied chickens to the Avon market pictured on page 28. (Courtesy Livingston County historian.)

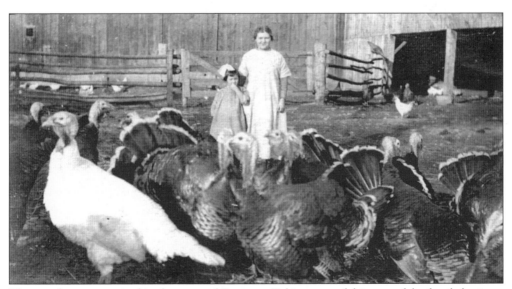

These turkeys were raised in the town of Geneseo. Taking care of this part of the family business was, according to this photograph, primarily women's work. (Courtesy Jane Black McBride.)

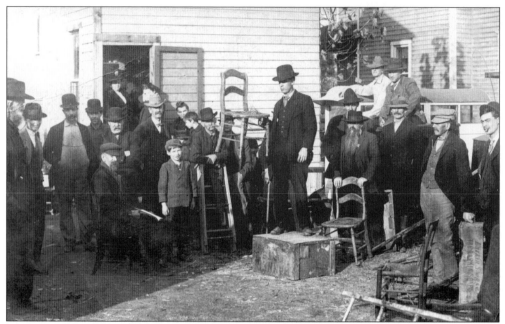

It may look as if the auctioneer is selling a chair, but the note on the back of the picture says that this is a horse auction in Leicester. (Courtesy Leicester town historian.)

IXIR

Will stand at my Barns One Mile South of Pine Tavern on the road leading to Gibsonville until further notice. To Insure Mare with Foal, $20, due April 1, 1916. If paid on or before and Foal is Lost at Birth, Service Privileges Free. Parties desiring more information should call at my place.

Both Phones

W. M. COOPER

Moscow, N. Y.

PERCHERON Society of America

Chicago, Ill. Incorporated under the Laws of the State of Illinois. Approved by the United States Government.

Certificate of Pedigree

The area around Geneseo was and is famous for its horses. Although some horses were bred for sport and leisure, many were work animals. This 1916 photograph of a breed of workhorse called the Percheron is a reminder that not all horses look like those seen in the Genesee Valley Hunt or in the movies. (Courtesy Leicester town historian.)

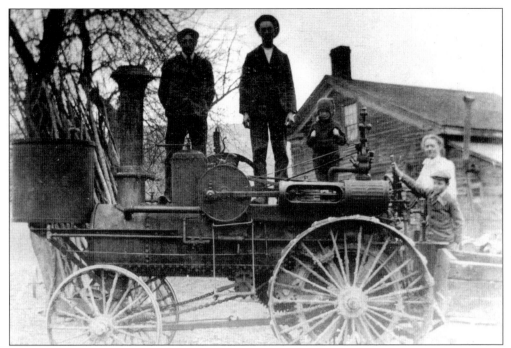

When this threshing machine came to a farm in Gibsonville (town of Leicester) c. 1900, the whole family wanted to see it do its magic. (Courtesy Livingston County historian.)

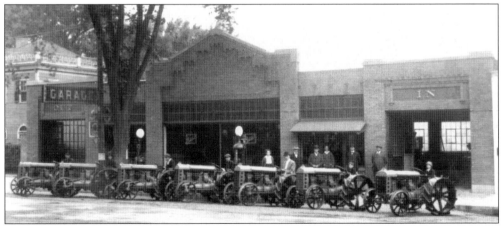

The tractors are ready to roll out of the garage on Main Street in Geneseo. The changes in agricultural technology that the two photographs on this page illustrate made possible the growth of cities that changed the face of America in the 20th century. (Courtesy Livingston County historian.)

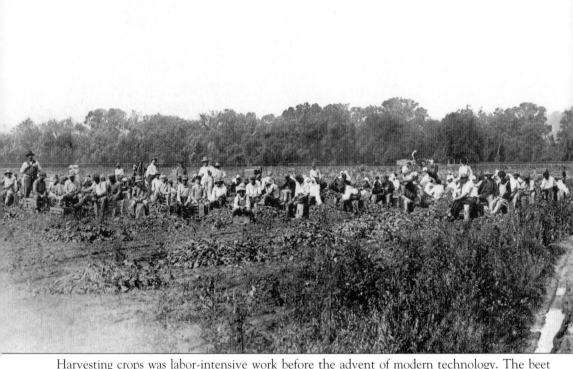

Harvesting crops was labor-intensive work before the advent of modern technology. The beet harvest in the mucklands required many workers, here mostly Italian immigrants. Until recently, there have been migrant workers to do harvesting in the Genesee Valley. Today, temporary residents from Puerto Rico still work in the seasonal food-processing industry, and immigrants from Mexico are employed in area dairy farms. (Courtesy Mount Morris town historian.)

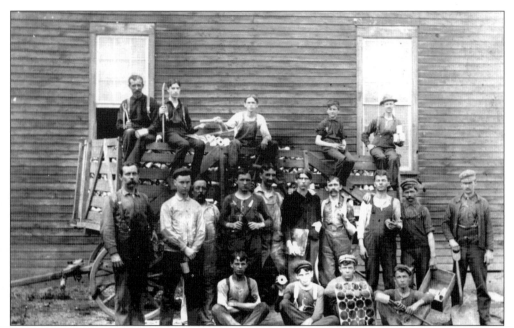

A day's work pulling onions was hard, and some of the laborers were quite young. This photograph was taken *c.* 1900 near Mount Morris. (Courtesy Mount Morris town historian.)

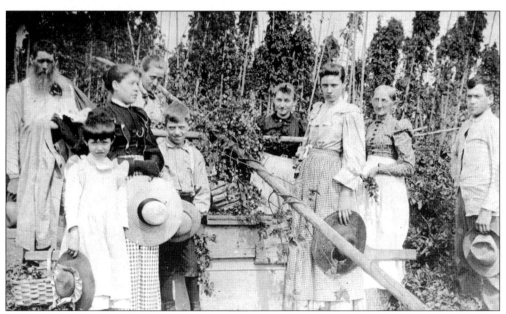

Some crops once grown in the Genesee Valley have long ago disappeared from the landscape. This is a hops harvest on a farm in the town of Leicester *c.* 1895. A mold came to the area soon afterward and destroyed hops farming here. The harvest appears to have been a family affair, and this photograph may have been taken in connection with some sort of celebration of the harvest; after all, the man on the far left hardly looks clad for farm labor. (Courtesy Leicester town historian.)

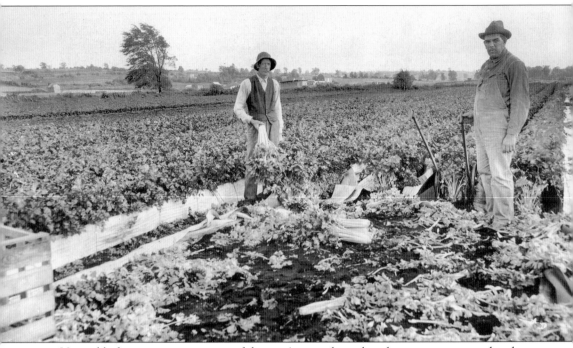

Vegetable farming remains a part of the area's agriculture, but there are no more celery harvests like this one in the town of Livonia. (Courtesy Livingston County historian.)

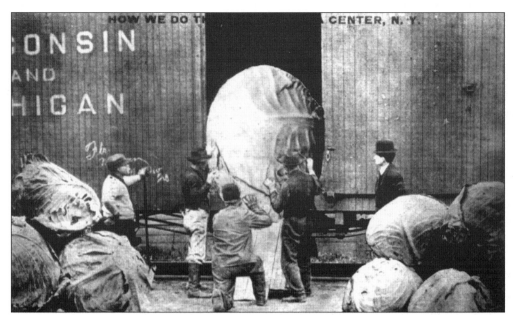

The growing of vegetables was an important part of the area's agricultural output. However, even in fertile Livonia, there were no cabbages as big as the one seen on this gag postcard. (Courtesy Livonia town historian.)

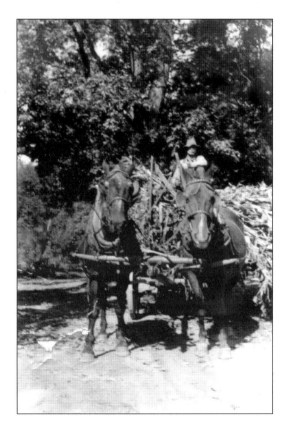

Crops had to get to market. This York farmer has hitched up his team of horses to start the journey of his corn from field to fodder. (Courtesy Laurel Buchinger.)

This photograph of a harvester in Livonia speaks volumes to the arduous labor that was necessary a century ago for the area to feed itself and the nation. (Courtesy Livonia town historian.)

Six

RECREATION
AND LEISURE

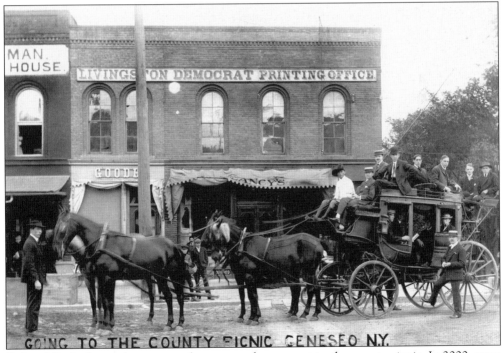

Before folks had cars, the stagecoach was a good way to get to the county picnic. In 2000, some ninety years after this photograph was taken, Livingston County had a picnic to celebrate the new millennium. (Courtesy Livingston County historian.)

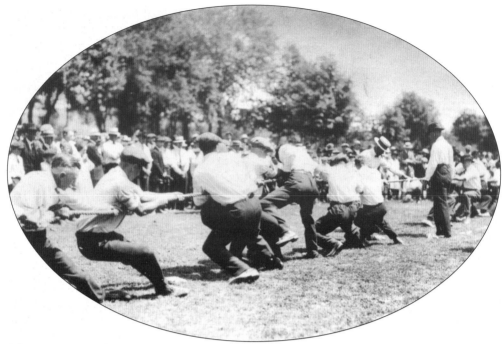

After arriving at the county picnic, many of the men joined in this tug of war. (Courtesy Cornell Cooperative Extension of Livingston County.)

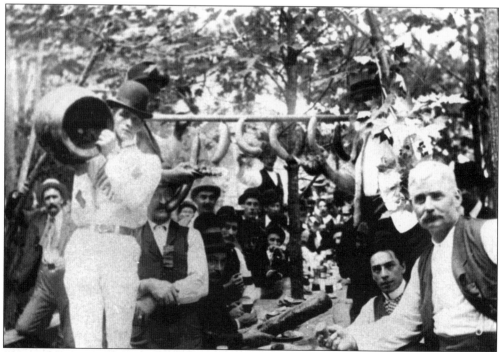

The sausages and beer define this as a German picnic in Mount Morris. All of the towns around Geneseo have the riches of many layers of ethnic cultures. (Courtesy Mount Morris town historian.)

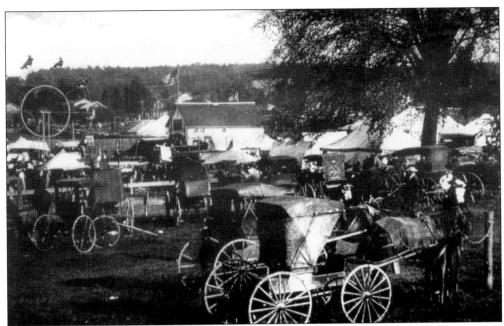

Livingston County is so large and so rich in agriculture that it has two county fairs. This photograph, probably taken shortly after 1900, shows the Hemlock Fair in the town of Livonia. (Courtesy Livonia town historian.)

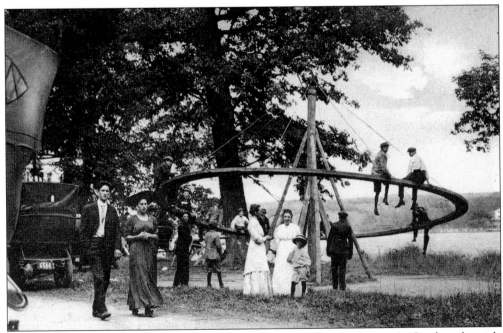

Adults enjoy the pleasant weather, while children play on the circular swing. On the other side of Conesus Lake is one of the hotels that used to line the shores. (Courtesy Tom Roffe.)

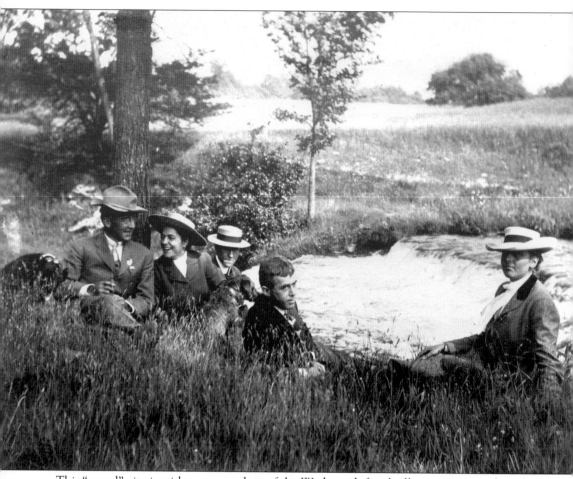

This "casual" picnic with some members of the Wadsworth family illustrates a more formal age. (Courtesy SUNY Geneseo, Milne Library.)

This happy couple from the town of York was married *c.* 1920. (Courtesy J. Marilyn Yasso.)

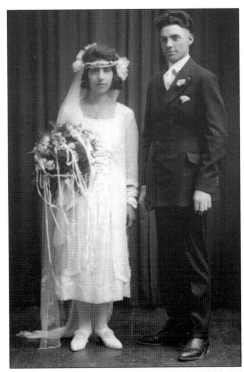

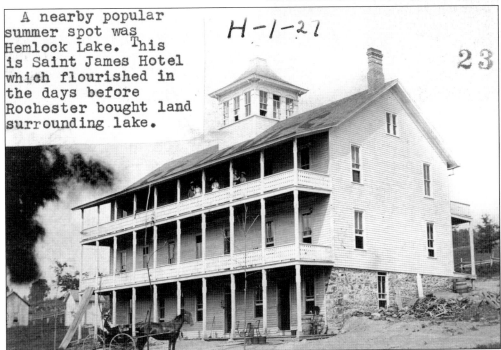

A nearby popular summer spot was Hemlock Lake. This is Saint James Hotel which flourished in the days before Rochester bought land surrounding lake.

H-1-27

23

Some 100 years ago, Hemlock Lake was returned to its natural state after having become a reservoir for Rochester. However, before that occurred, the lake was a popular recreation and tourist destination, as evidenced by the St. James Hotel on its shores. (Courtesy Livingston County historian.)

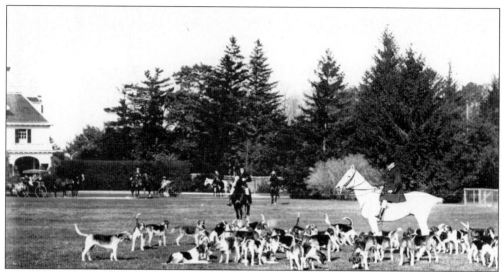

The surrey with the fringe on top (far left) may no longer be a part of the Genesee Valley Hunt, but not much else has changed. (Courtesy Livingston County historian.)

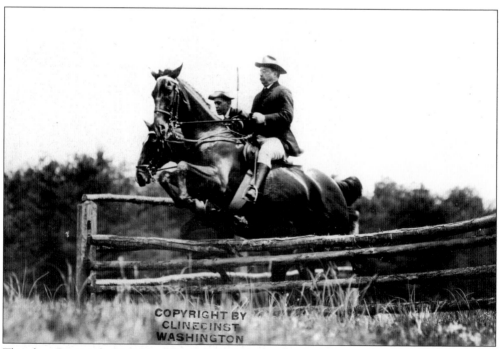

COPYRIGHT BY
CLINEDINST
WASHINGTON

Theodore Roosevelt (right) and his companion are not charging up San Juan Hill but rather participating in the Genesee Valley Hunt. The companion is a member of the Wadsworth family, and this photograph was taken in 1907, when Roosevelt occupied the White House. No security is visible for the 26th president of the United States. (Courtesy SUNY Geneseo, Milne Library.)

The Genesee Valley Hunt has met for more than a century. Although many people who are not rich participate in the activities every fall, there are still touches of elegance that reflect the aristocratic origins of the hunt. (Courtesy Livingston County News.)

Mrs. William Wadsworth probably served tea often in her estate. Here, however, she rather incongruously serves tea to spectators and a jockey during the Genesee Valley Hunt. (Courtesy Livingston County historian.)

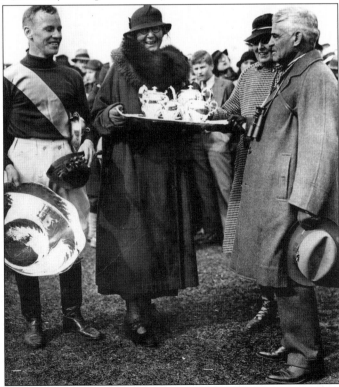

The Genesee Valley Hunt may have elegance, but this photograph suggests that the most successful fox hunters belonged to the Little Beard's Rod and Gun Club of Leicester. (Courtesy Leicester town historian.)

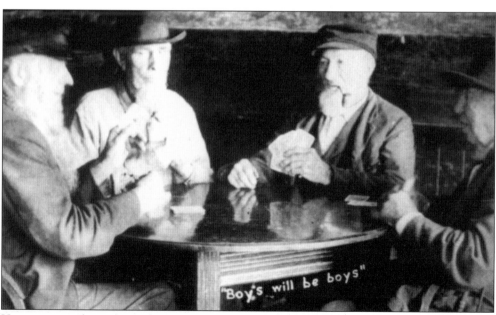

Here are some "boys" (note the inscription) enjoying a game of cards at the Metropolitan Hotel in Hemlock (town of Livonia) c. 1905. (Courtesy Livonia town historian.)

This early balloon launch somewhere near Geneseo and the photograph below of an early airplane pilot suggest that local people were fascinated by the beginnings of travel through the air. These people traveled only a few miles by air; by the end of the 20th century, another local man, Jim Adamson (see page 55), had journeyed hundreds of thousands of miles, orbiting the earth in the space shuttle. (Courtesy SUNY Geneseo, Milne Library.)

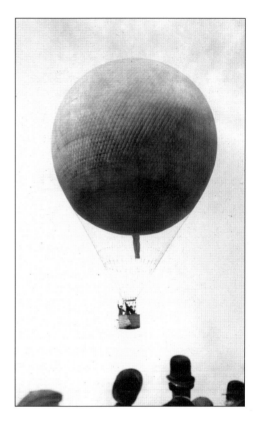

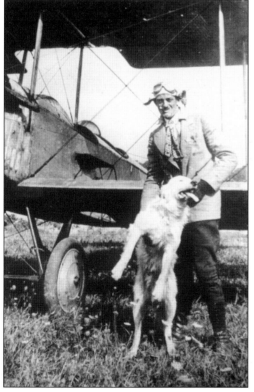

This early pilot probably enjoyed the thrill of flying rather than flying as a means of making a living. The first airplane landed in Livingston County in 1911. (Courtesy Edward De Graff.)

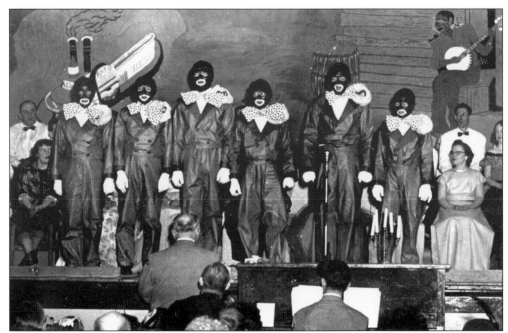

Blackface minstrel shows were a popular form of entertainment in the second half of the 19th century and first half of the 20th century. This was one put on by the Hemlock Valley Fire Department (town of Livonia). Only in the era of the civil rights movement were such traditions finally terminated in this area. (Courtesy Livonia town historian.)

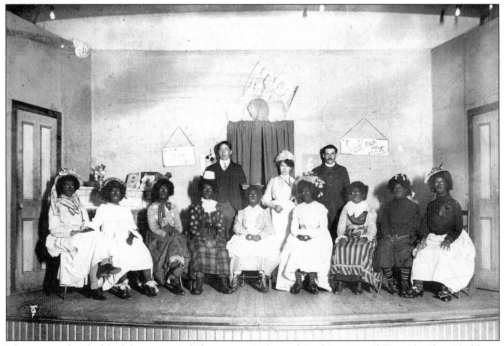

This unusual girls' blackface minstrel show was performed in the town of Groveland, probably at the high school. The significance of the two signs, which say, "I live for love" and "Never say die," is unclear, but they are presumably props for the show. (Courtesy Livingston County historian.)

Conesus Lake is the sort of place people should write songs about, and Jennings and Carleton did exactly that. (Courtesy Jim Kimball.)

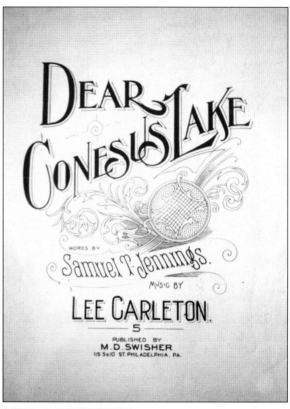

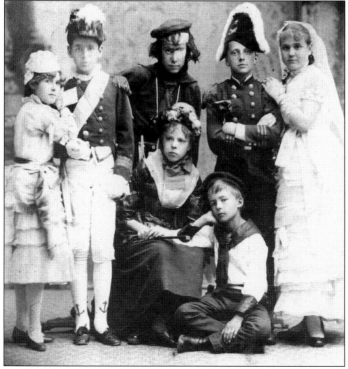

This is the cast of a Geneseo production of Gilbert and Sullivan's HMS *Pinafore c.* 1889. There is still a thriving amateur theater tradition in Geneseo. (Courtesy Livingston County historian.)

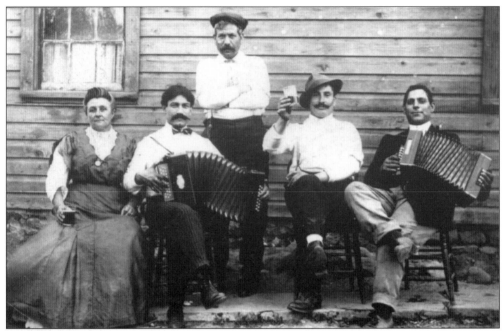

In an era before radio and phonograph, people made their own music. This is an Italian band at the Genesee Hotel in Retsof (town of York) in the first years of the 20th century. (Courtesy J. Marilyn Yasso.)

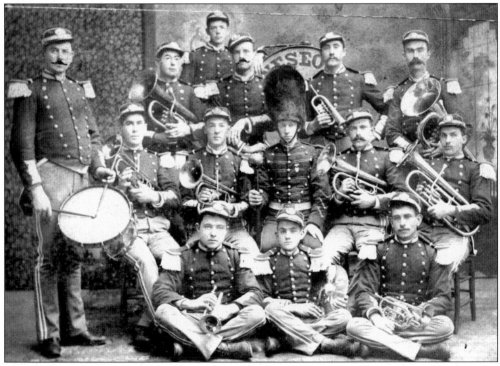

Geneseo may not be the mythical "River City," but it did have a brass band. (Courtesy Livingston County historian.)

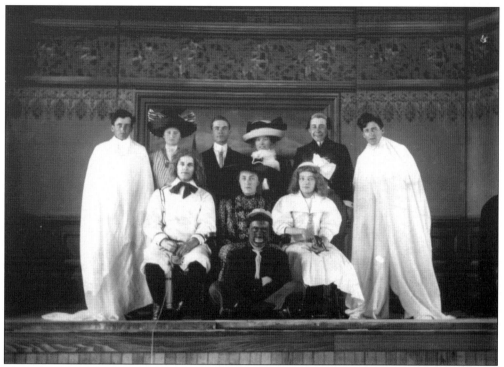

The title of this play has not survived, but the production was certainly an elegant one, performed at the Seymour Opera House in Mount Morris. (Courtesy Mount Morris town historian.)

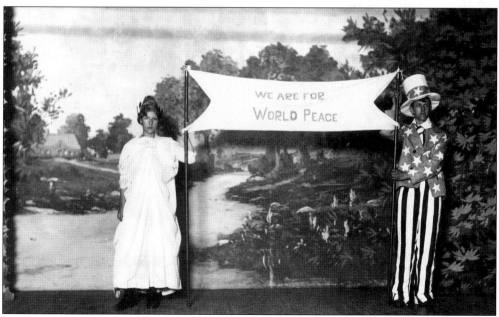

WE ARE FOR WORLD PEACE

These young people at Sonyea (town of Groveland) put on this pageant just before or just after World War I, "the war to end all wars." (Courtesy Livingston County historian.)

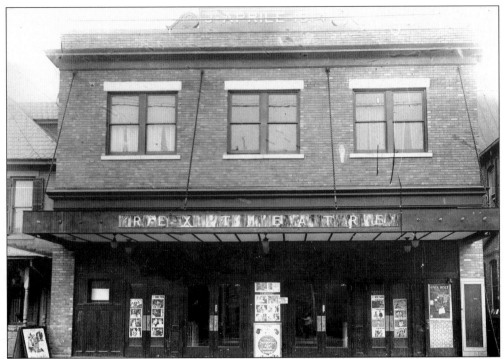

The Rex Theater (later the Riviera), on Center Street in Geneseo, was constructed in 1914. On the day this photograph was taken, the double feature was *The Gumps* (a silent film released in 1923) and *The Dangerous Age*. (Courtesy Livingston County historian.)

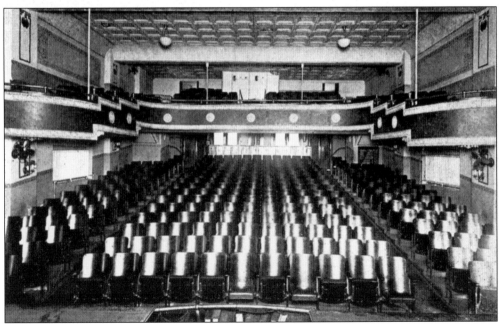

This is the classy interior of the Rex Theater as it appeared in its print advertisements. (Courtesy SUNY Geneseo, Milne Library.)

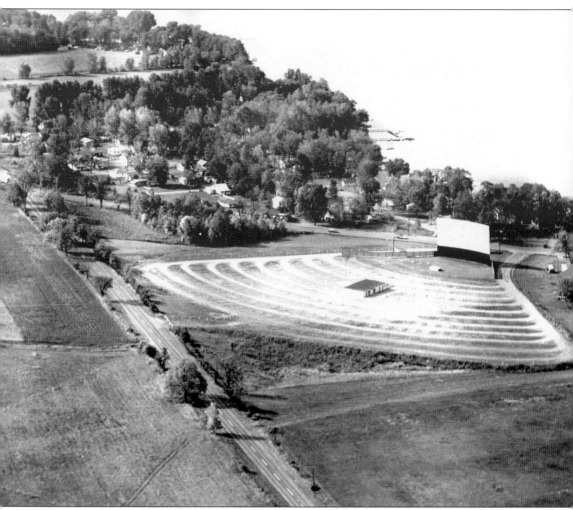

The drive-in movie theater on Conesus Lake became another option for seeing films, and it provided a lot of opportunities for young people to do something public (this is, after all, long before VCRs and DVDs and cable television) in relative privacy. (Courtesy Livonia town historian.)

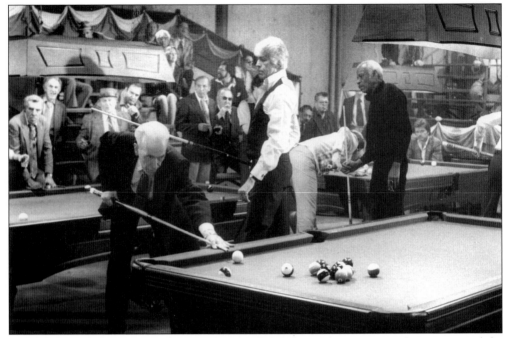

Livonia's Irving "Deacon" Crane shoots a pool shot for actor James Coburn (next to Crane) for the film *The Baltimore Bullet*. Crane, the greatest billiards player of his generation, was never able to get the more famous Minnesota Fats to play him. (Courtesy Irving Crane.)

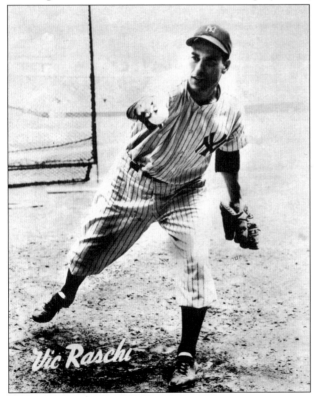

Vic Raschi, a Massachusetts native who made his home in Geneseo, was one of the great pitchers in New York Yankees history. Known as "the Springfield Rifle," Raschi was a hero in the five straight World Series victories of the Yankees from 1949 through 1953. The 1950 World Series had a Genesee Valley connection to both teams. Raschi pitched a shutout in game one over the Philadelphia Phillies, managed by Mount Morris native Eddie Sawyer. (Courtesy Livingston County News.)

Seven
HOME AND FAMILY

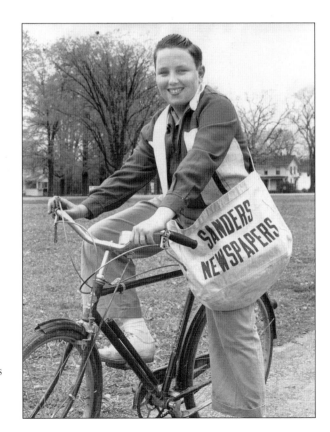

To be a paperboy was a high calling and a source of income for youngsters. This Leicester youth is delivering a local paper published in Geneseo. (Courtesy Leicester town historian.)

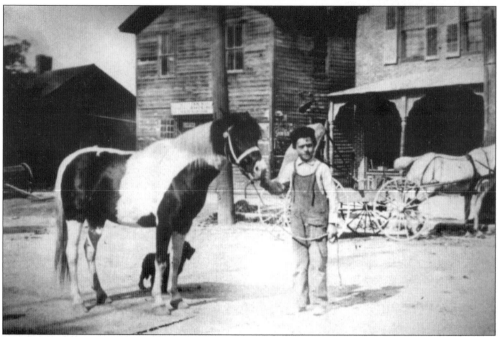

If one imagines life in the area 100 years ago, an image that might come to mind is that of a boy in overalls with a horse and a dog. This reality existed, at least on the streets of Avon. (Courtesy Avon town historian.)

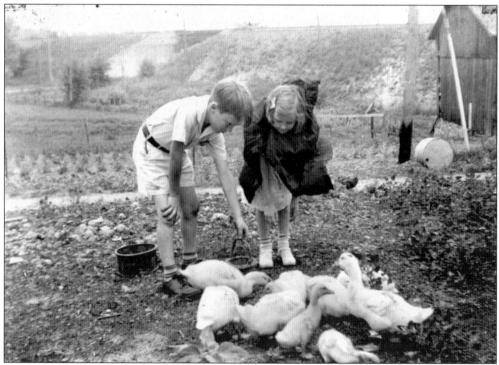

Part of home life, especially on a farm, was everyone sharing the work. These children from Leicester feed the geese in 1941. (Courtesy Leicester town historian.)

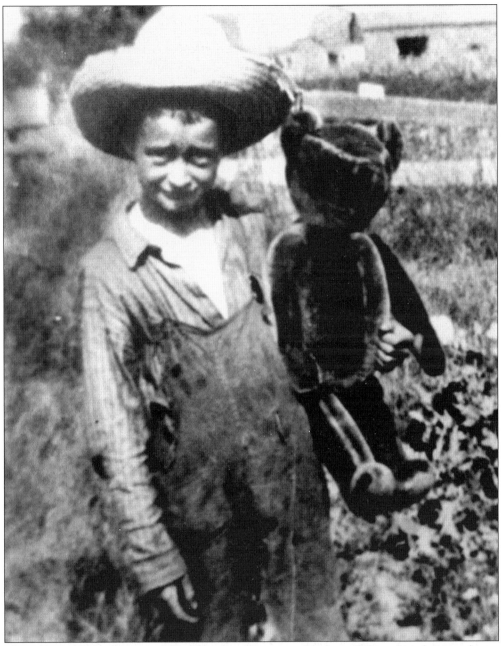

This Mount Morris boy grasps his prize possession, a teddy bear. When this photograph was taken in 1908, Teddy Roosevelt was president. (Courtesy Edward De Graff.)

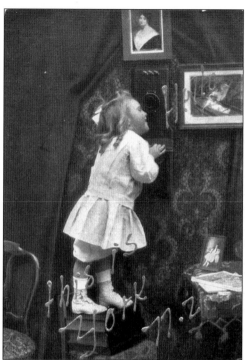

This postcard shows the impact of the telephone on life in general and in the home in particular. The girl might be saying, "This is York, New York" to someone hundreds or even thousands of miles away. (Courtesy York town historian.)

These children are unidentified, but they certainly appear to be weary of dressing up and posing. (Courtesy Livingston County historian.)

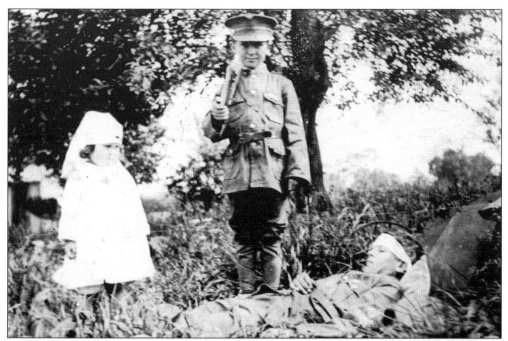

Children have always played soldier, but the game becomes a more poignant activity in time of war. During World War I, these children from Ridge (town of Mount Morris) play "doughboy," complete with an injured soldier, his buddy, and a nurse. (Courtesy Gail Demos.)

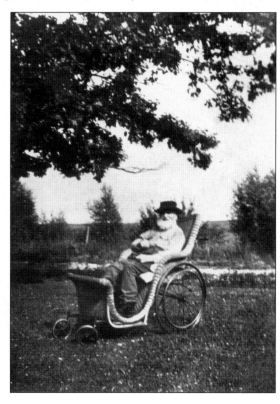

This man in Leicester was fortunate to have someone make him a wheelchair. Wheelchairs did not come into common use until well after the time of this photograph, 1916. (Courtesy Velma Mahoney.)

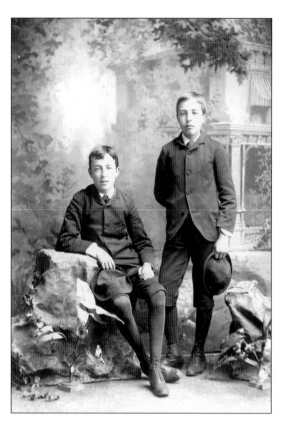

This beautifully posed photograph, dating from *c.* 1880, shows brothers James S. (left) and Craig W. Wadwsorth. (Courtesy Livingston County historian.)

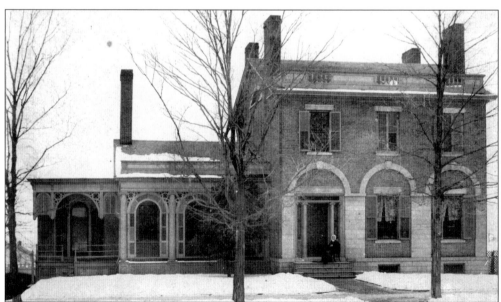

Pictured is the Ayrault home, on Main Street in Geneseo. The woman on the porch is probably Mrs. Ayrault. Later, a third story was added to the right portion and the far left porch was walled in and a story added there as well. The building is now the Big Tree Inn. (Courtesy Livingston County historian.)

This home on Oak Street in Geneseo looks today much like it did a century ago when it was built, except for an addition on the back. (Courtesy Livingston County historian.)

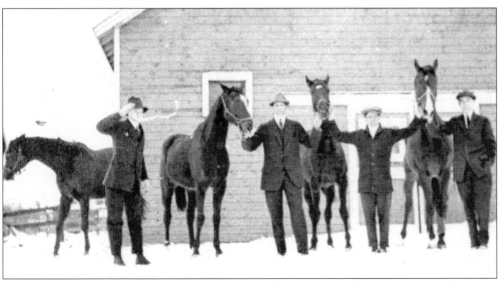

This frisky group of horses lived in a stable on Oak Street in the village of Geneseo. (Courtesy Livingston County historian.)

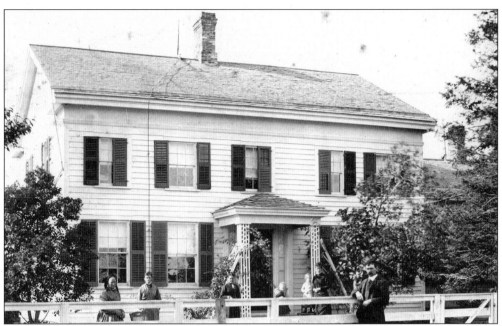

Like many homes 100 years ago, this one on Groveland Road probably contained three generations living under the same roof, judging from the people posing here. (Courtesy Livingston County historian.)

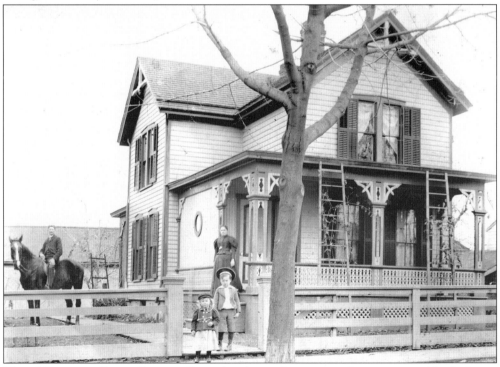

This old home on Center Street, still standing but without its porch, was presumably the home of the man on the horse, his wife on the porch, and two children with wonderful hats. (Courtesy Livingston County historian.)

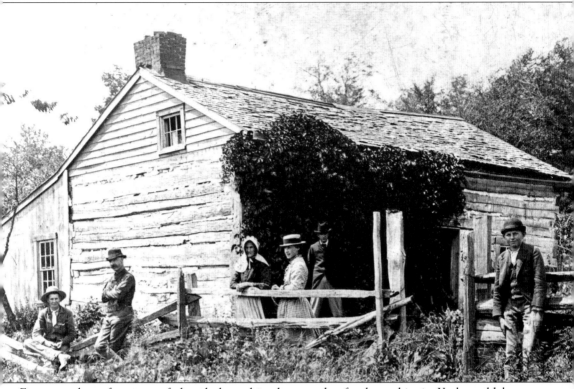

Except perhaps for some of the clothes, this photograph of a log cabin in York could be mistaken for one of a pioneer family out West. (Courtesy Livingston County historian.)

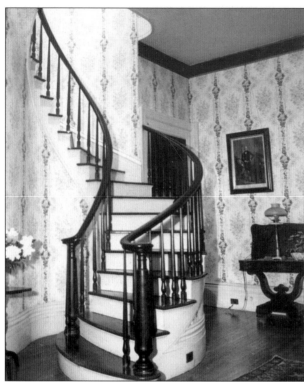

This elegant interior is a reminder of how "civilized" Geneseo was. Gov. John Young (1847–1849) once lived in the house on Second Street. He headed west from Vermont to Livingston County when he was four years old, practiced law in Geneseo, and served two terms in the U.S. Congress. He is buried in Temple Hill Cemetery in Geneseo. (Courtesy Livingston County historian.)

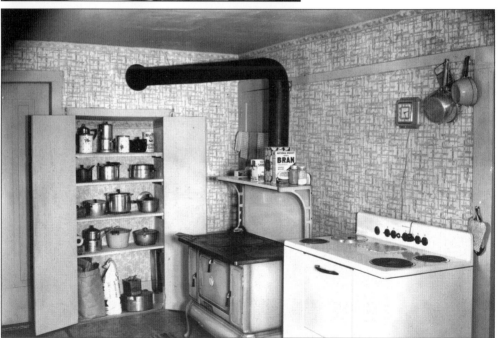

The new electric stove replaces the older one that burned wood. New home conveniences and the prosperity needed for most people to afford them changed not only home life but also the demographics of the workforce, as more women took jobs. (Courtesy Cornell Cooperative Extension of Livingston County.)

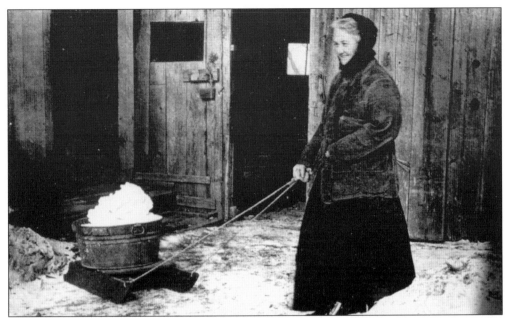

This woman needed fresh water, and so she found an easy solution: put a tub of snow on a sled and slide it to the house, where it can be heated. The photograph was taken in Livonia in 1915. (Courtesy Livonia town historian.)

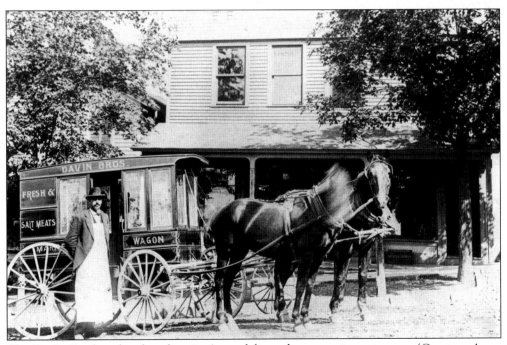

The Davin Brothers butcher shop in Avon delivered meat to its customers. (Courtesy Avon town historian.)

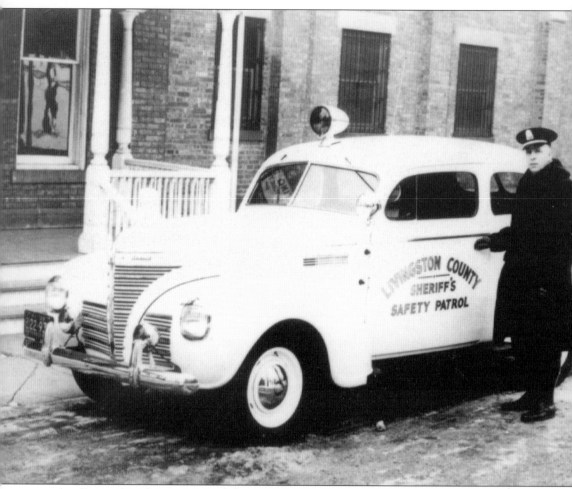

A village police department and the Livingston County sheriff's office have provided security for local citizens in their homes and on their streets. This patrol car is parked at the sheriff's office, near the courthouse. (Courtesy Livingston County sheriff.)

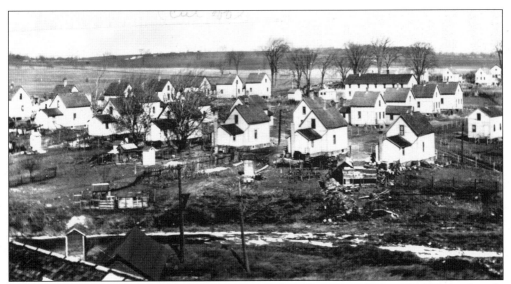

Retsof (town of York) was a company town for the salt miners. Its population was largely Italian. In addition to the homes, a boardinghouse is visible in the upper right of the photograph. (Courtesy J. Marilyn Yasso.)

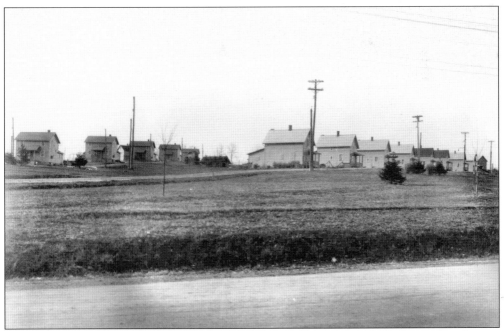

This rare photograph shows the often forgotten village of Halite, a mining community adjacent to Cuylerville (town of Leicester). Today, only some of the foundations are still visible. (Courtesy Joe Bucci.)

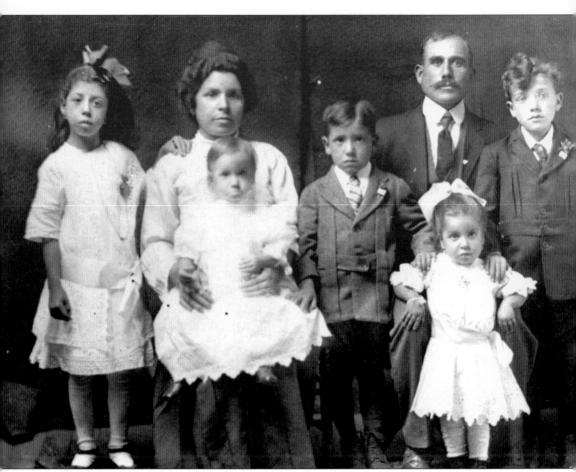

Formal portraits allowed people to be portrayed with dignity and became family heirlooms. This beautiful portrait is of an Italian immigrant family in Mount Morris in 1916. The parents almost certainly did manual labor. One easily imagines the man building the railroad or doing field work in the mucklands while his wife probably either worked in a knitting mill or a food-processing plant. (Courtesy Dianne Cicero.)

Eight
SCHOOL DAYS

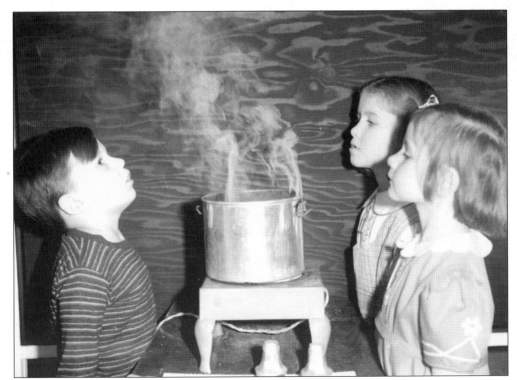

It is fun and perhaps even mystical to learn that water can be transformed into a gas—at least it must have been for these Geneseo schoolchildren at the college's campus school. (Courtesy Livingston County historian.)

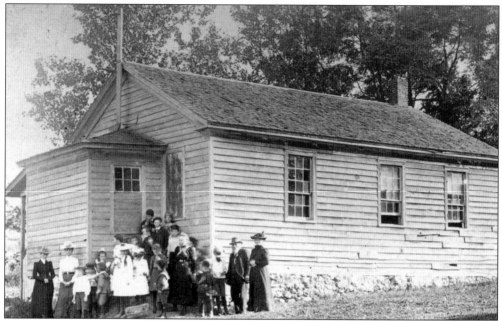

The Littleville School in Avon is typical of the one-room schools that dotted the rural landscape in the area until the mid-20th century. The teacher is one of the young women on the left. (Courtesy Livingston County historian.)

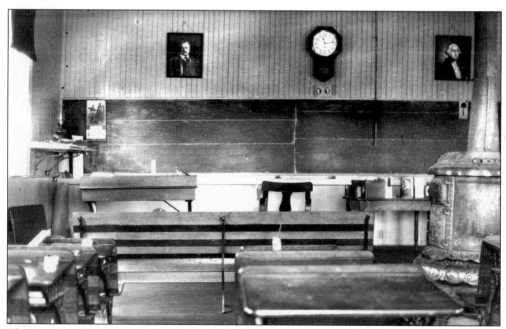

The interior of Geneseo District 3 School displays a picture of George Washington and the president at the time, Teddy Roosevelt. The room was heated by the potbelly stove on the right and lit by the kerosene lamp on the shelf to the left of the blackboard. (Courtesy Livingston County historian.)

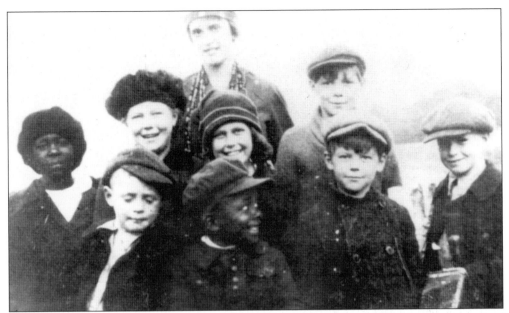

This unusually informal photograph of Avon schoolchildren is a reminder that Avon once had a significant African American population. (Courtesy Livingston County historian.)

Maybe those stories of children a long time ago walking five miles each way to school (uphill both ways, of course) are something of an exaggeration. In any case, this odd-looking rig took three boys to Taunton School in the town of Leicester in 1930. (Courtesy Leicester town historian.)

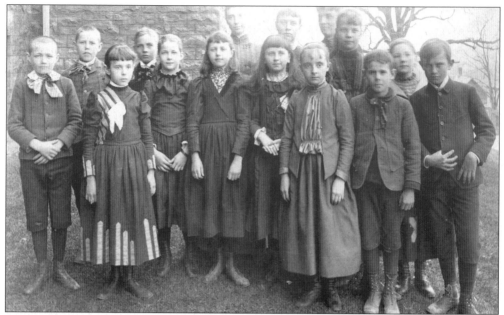

It is uncertain whether these Geneseo schoolchildren got dressed up for this photograph or whether this was their normal school attire. (Courtesy Livingston County historian.)

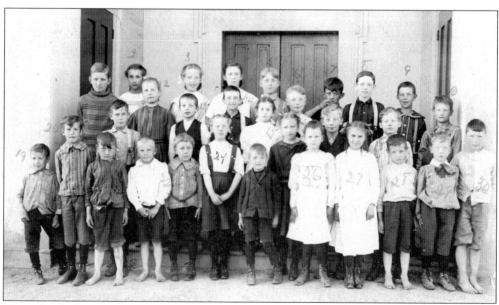

The school photograph from the town of Leicester shows children who perhaps did not own fancy clothes. Note that at least four of the boys are barefoot. (Courtesy Livingston County historian.)

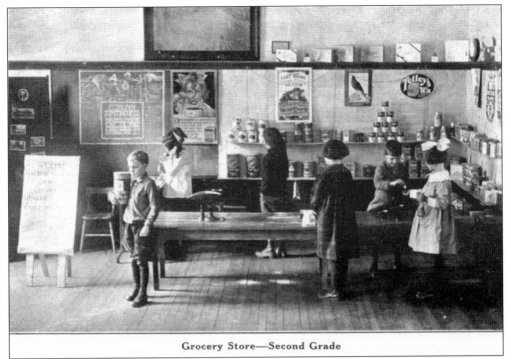

Grocery Store—Second Grade

The 1921 second-grade class at Geneseo's elementary school is not studying the three R's at this moment but rather learning how to shop in a grocery store. Consumer education started early. (Courtesy SUNY Geneseo, Milne Library.)

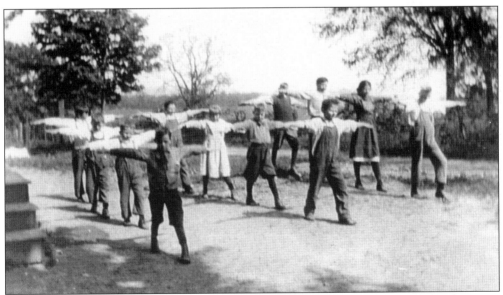

There is no gym for physical education class at Groveland District 2 School. This 1921 photograph shows that this school contained several grades because the size of the children varies a great deal. (Courtesy Livingston County historian.)

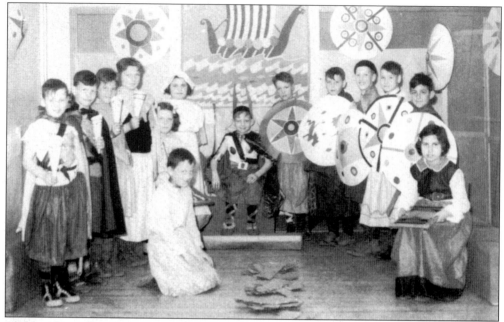

Children have always put on pageants as part of the process of learning about other times and places. Here, children at the Holcomb School, Geneseo's grade school that was part of the college, dress up as Vikings. (Courtesy SUNY Geneseo, Milne Library.)

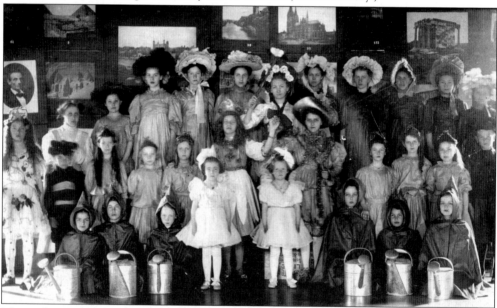

This is the cast of a springtime pageant in Livonia. The costume of the girl on the far left and the presence of the watering cans in the front hint at the theme of the presentation. On the wall of the classroom are large photographs of ancient Egyptian pyramids and sculpture, the Tower of London, the cathedrals of Durham (England) and Cologne (Germany), and a small temple on the Acropolis in Athens (Greece). The study of history at this time was very much Europe oriented. To these classic monuments is added a photograph on the left of Abraham Lincoln. (Courtesy Livonia town historian.)

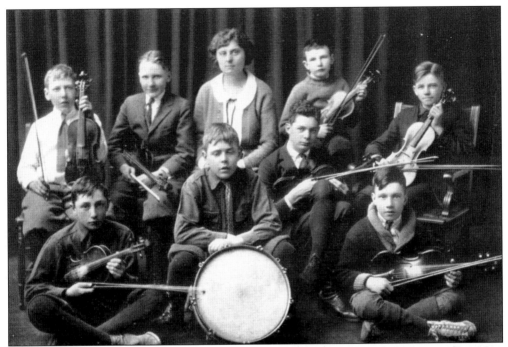

Here is Geneseo's junior high school orchestra of 1923. Apparently only boys were allowed to play in it, although the teacher is a woman. (Courtesy SUNY Geneseo, Milne Library.)

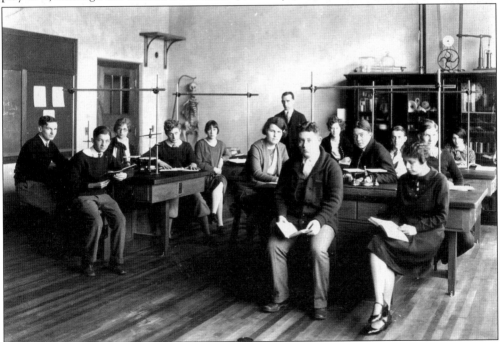

This 1927 science class at Livonia High School is a stark contrast to its counterpart of today, which depends on expensive equipment and experimentation. Here, the books seem to be more prominent than the skeleton or the pieces of equipment stored in and on top of the cabinet on the right. (Courtesy Livonia town historian.)

After school and during the summer months, schoolchildren found numerous ways to entertain themselves. This youngster from Leicester proudly poses in the driver's seat of the Soap Box Derby car that he built with the help of his father. (Courtesy Leicester town historian.)

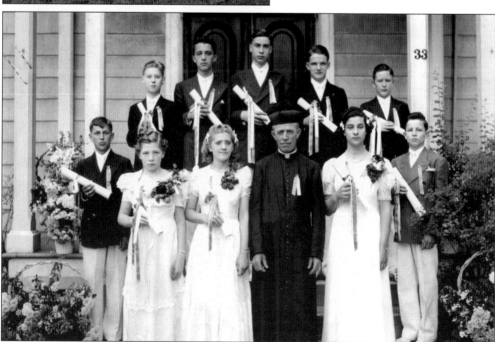

Posing here is the class of 1941 of St. Patrick's School in Mount Morris. When the United States entered World War II (only months after this photograph was taken), many of these recent graduates' lives changed drastically from what they had been planning when they posed on graduation day. (Courtesy Mount Morris town historian.)

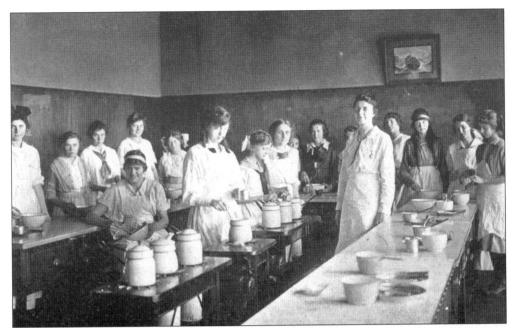

Since most women in the first part of the 20th century did not work outside the home, classes such as this one in 1917 teach girls valuable skills and perhaps some new techniques that their mothers could not teach them. (Courtesy York Central School.)

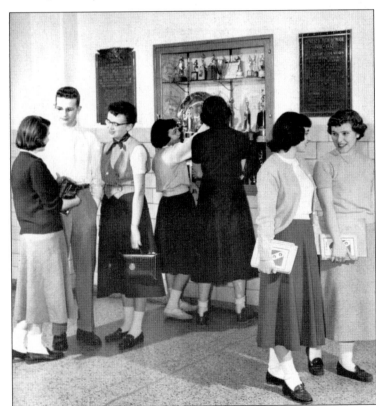

This casual glimpse of high school life in Geneseo in 1952 was probably carefully staged. Nevertheless, the long skirts, bobby socks, and loafers were still very "hep" at that time. (Courtesy Geneseo Central School.)

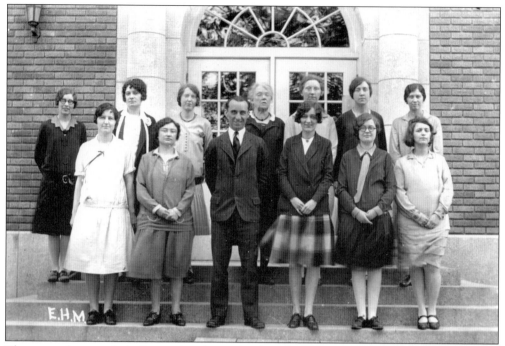

These two photographs indicate a lot about schools and job opportunities. The one above shows the faculty of Livonia High School in 1927; the education of Livonia's youth was almost entirely in the hands of women. The photograph below, also taken in 1927, shows the Livonia School Board; those who made school policy were all males. (Courtesy Livonia town historian.)

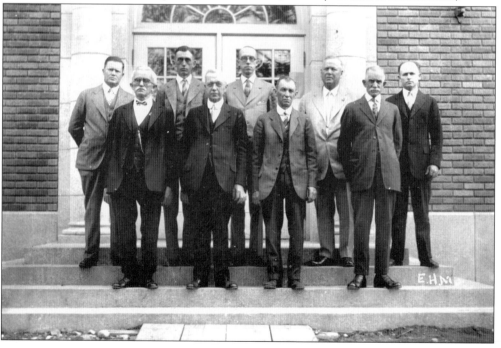

FRED TOTTEN

Glee Club 3, 4; Band 1, 2, 3, 4; Orchestra 3, 4; Football 4.
I've taken my fun where I found it. — *Washington*
Beer + Breakfast in my room —
Fred Totten

This yearbook photograph of Fred Totten, Geneseo High School class of 1933, is a reminder that school trips can be nightmares for teachers and chaperones. Totten's class went to Washington, D.C., in 1933. His "confession" was written next to his photograph in the yearbook of a classmate. Prohibition was still the law of the land in the spring of 1933; however, Pres. Franklin Delano Roosevelt had signed legislation making the sale of 3.2 percent beer legal in the District of Columbia as of April 7, 1933. Totten and his classmates must have been the first to buy what came to be called "near beer." (Courtesy Geneseo Central School.)

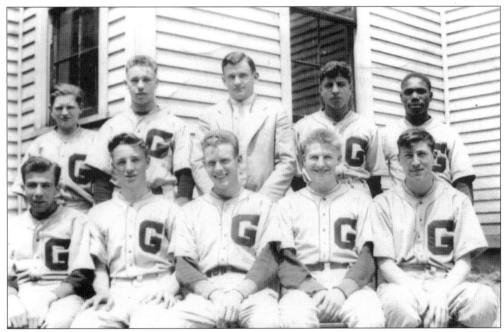

This is the 1941 Groveland High School baseball team. Most of these boys were forced to grow up quickly after Pearl Harbor. Since there were only nine players on the team, one can only hope that they were injury free during their season. (Courtesy Mrs. Robert Kane.)

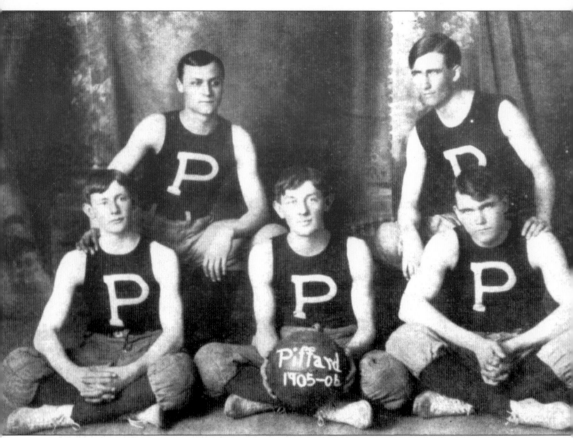

School consolidation and the creation of central schools provided lots of opportunities for children to learn. However, the loss of these schools has contributed to a decline in community solidarity. The Piffard (town of York) basketball team of 1905–1906 certainly could not afford injuries or players fouling out of a game. (Courtesy York town historian.)

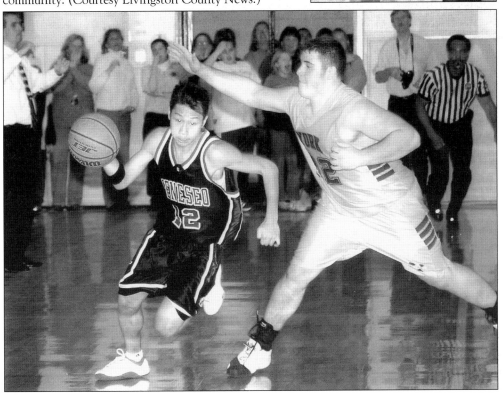

The leaping Geneseo Central basketball player to the right is Puerto Rican. He moved to Geneseo at age 14. His presence is a reminder that a significant number of Latinos and Latinas have made the Geneseo area their home. The Geneseo Central player below arrived at age four as a refugee from Vietnam. Together, these two boys illustrate that team sports is one of the best ways for new groups to assimilate into the school and community. (Courtesy Livingston County News.)

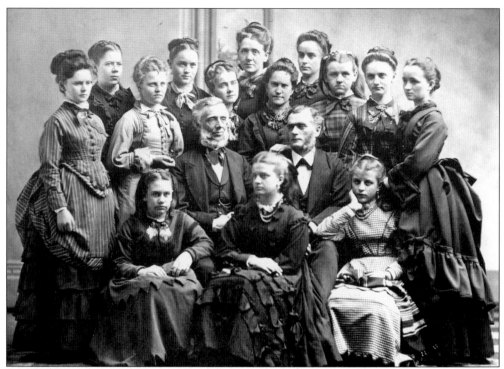

The faculty of Temple Hill Academy, a private school that educated a U.S. president (Chester A. Arthur) and a Japanese admiral (S. Oyama), poses for a formal photograph. (Courtesy Livingston County historian.)

This is a sketch of Temple Hill Academy. One of the buildings still stands on Temple Hill Road across from the cemetery in the village of Geneseo. Note the plank road in front. (Courtesy Livingston County historian.)

Nine
THE COLLEGE

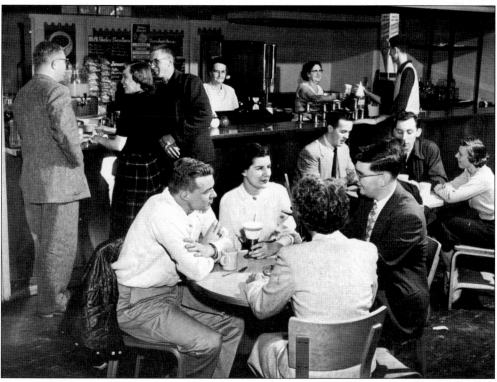

This 1954 photograph shows rather sophisticated students enjoying themselves at a soda fountain. While the young man seated at the table to the left enjoys a cup of coffee, the woman next to him is having a soda in a cone-shaped paper cup held in place by a metal base. The man standing at the far left is smoking a cigarette, a reminder of a time when No Smoking signs were nonexistent and smoking was glorified in the movies and the new medium of television. (Courtesy SUNY Geneseo Libraries.)

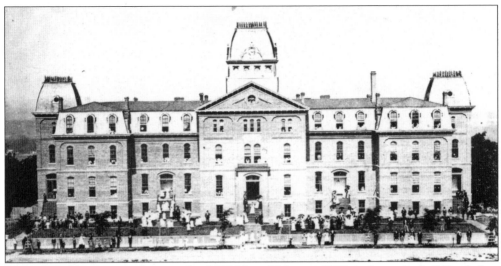

This is the oldest known photograph of Old Main. Taken in 1873, it shows the building before the addition of a porch. The building faced Wadsworth Street. Today, Wadsworth Auditorium and Erwin Hall stand on the site of Old Main. (Courtesy Livingston County historian.)

Even this informal picture of the faculty of the college (normal school) shows the men and women in dress clothes, drinking tea poured from a silver teapot. (Courtesy Livingston County historian.)

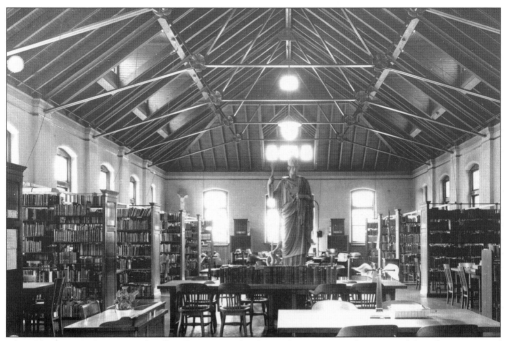

The library of the normal school consisted of one large room dominated by the statue of Minerva, goddess of wisdom. (Courtesy Livingston County historian.)

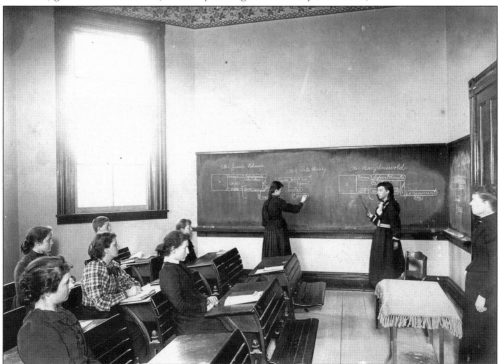

These women are writing grammar lessons on the blackboard. The students' desks are similar to ones they had used throughout grade school and high school. (Courtesy Livingston County historian.)

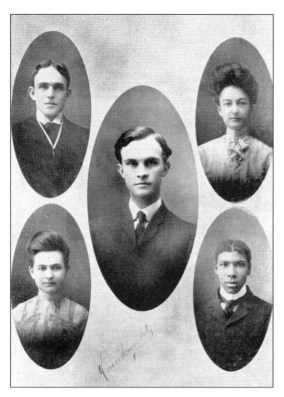

The officers of the Geneseo State Normal School class of 1905 included a young man from Caledonia who is believed to be the first African American to graduate from the college. (Courtesy SUNY Geneseo, Milne Library.)

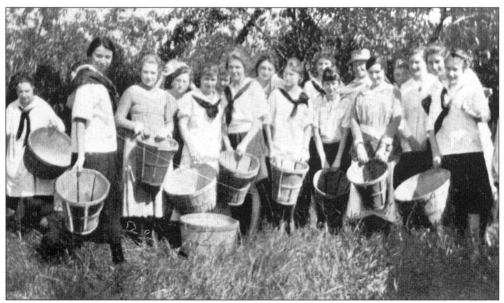

Students at the normal school, more than 90 percent of whom were women, did peach harvesting during World War I because so many men were away at war. Early in the century, peaches were an important cash crop in the Geneseo area. (Courtesy SUNY Geneseo, Milne Library.)

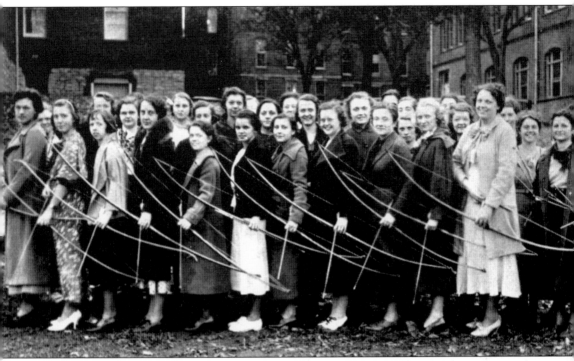

This photograph, which appeared in the 1935 college yearbook, testifies to the popularity of archery. One hopes that the practicing did not harm town-gown relations. (Courtesy SUNY Geneseo, Milne Library.)

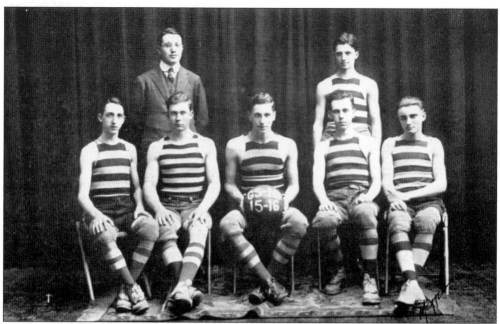

Geneseo State Normal School's basketball team for the year 1915–1916 must have been easy to see no matter where it practiced or played. (Courtesy SUNY Geneseo, Milne Library.)

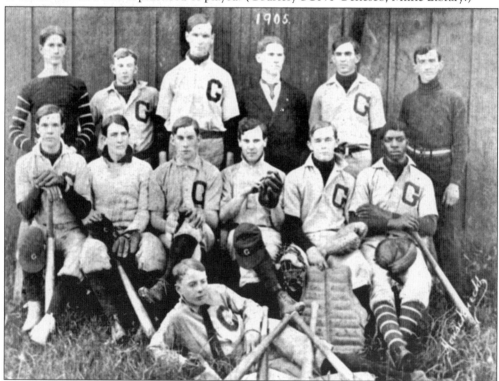

Although the great majority of students at the normal school were women, there were enough men to field athletic teams. The man seated at the right was also a class officer in 1905 (see page 120). (Courtesy SUNY Geneseo, Milne Library.)

In this 1927 photograph, it is clear that the normal school had a variety of athletic experiences for both men and women, long before Title IX required colleges to have equality. (Courtesy SUNY Geneseo, Milne Library.)

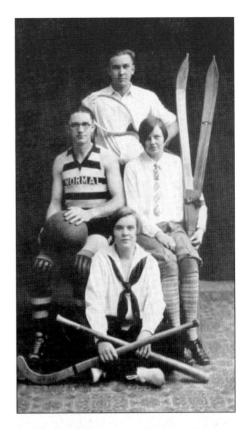

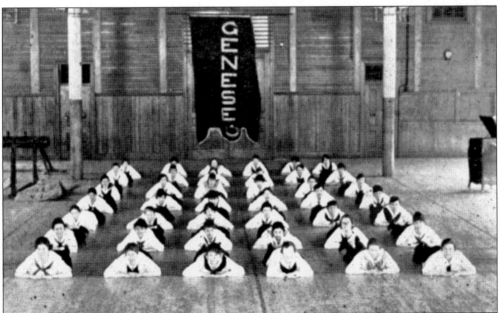

Physical fitness was an important part of the collegiate education of students at the normal school. This class met in the gymnasium that was a part of Old Main. (Courtesy Livingston County historian.)

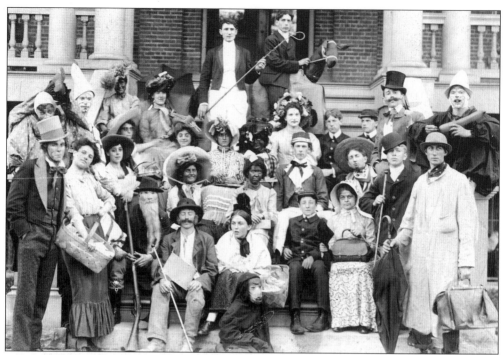

Apparently being a student at the normal school involved play as well as work. These students were part of a carnival in 1903. (Courtesy Livingston County historian.)

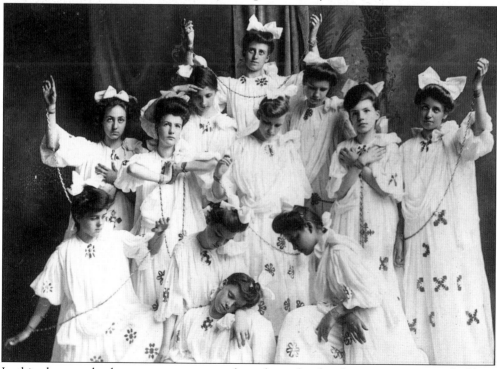

In this photograph, these young women are bound together by chains in some sort of tableau put on at the normal school. (Courtesy Livingston County historian.)

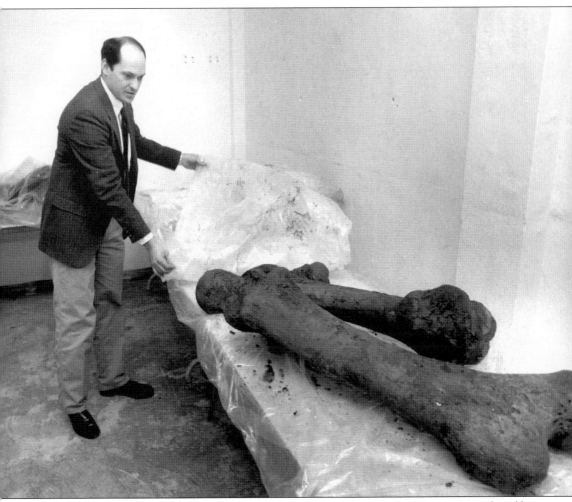

When the bones of a mastodon were discovered in the town of Avon during construction of a golf course, the college's Anthropology Department was called to examine and care for them. This discovery provided an excellent teaching and learning opportunity for faculty and students. (Courtesy SUNY Geneseo, Milne Library.)

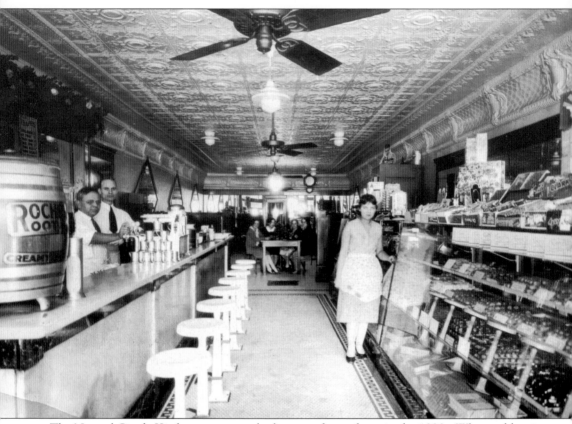

The Normal Candy Kitchen was a popular hangout for students in the 1920s. Who could resist root beer from a barrel and all that candy in the cases on the right? (Courtesy Geneseo town historian.)

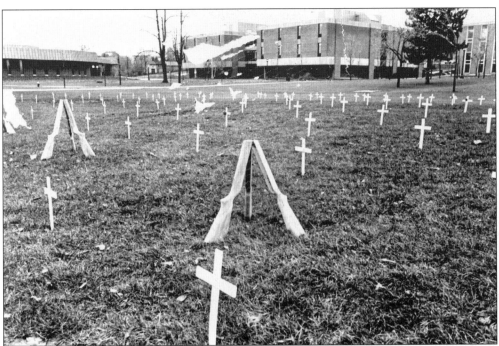

Although SUNY Geneseo was hardly Columbia or Berkeley or Cornell, its students also protested against the Vietnam War and against the establishment. The photograph above shows wooden guns and crosses placed on the college's main quad to protest the war in Vietnam. To the right, a student advertises an "impeach President Nixon" rally in the fall of 1973. (Courtesy SUNY Geneseo, Milne Library.)

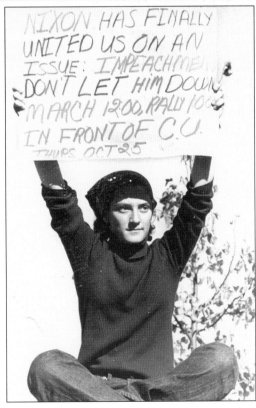

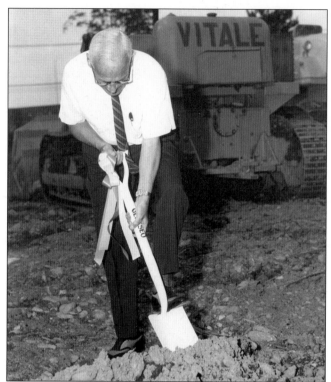

Francis Moench, president of the college, breaks ground for the construction of Bailey Hall. It was the expansion of the campus that led to the destruction of a large part of Wadsworth Street and the homes that lined it. (Courtesy Livingston County historian.)

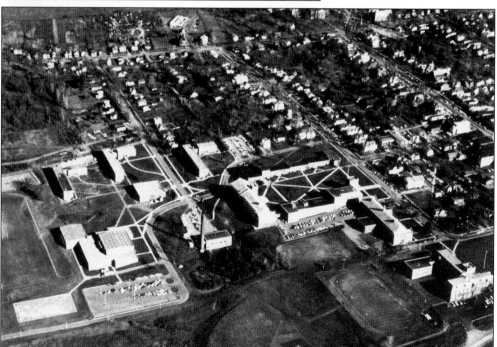

An aerial view of the college's campus in the late 1950s shows the beginning of the campus building program. However, Wadsworth Street still stretches from Court Street to the old high school, now known as the Doty Building. (Courtesy Livingston County historian.)